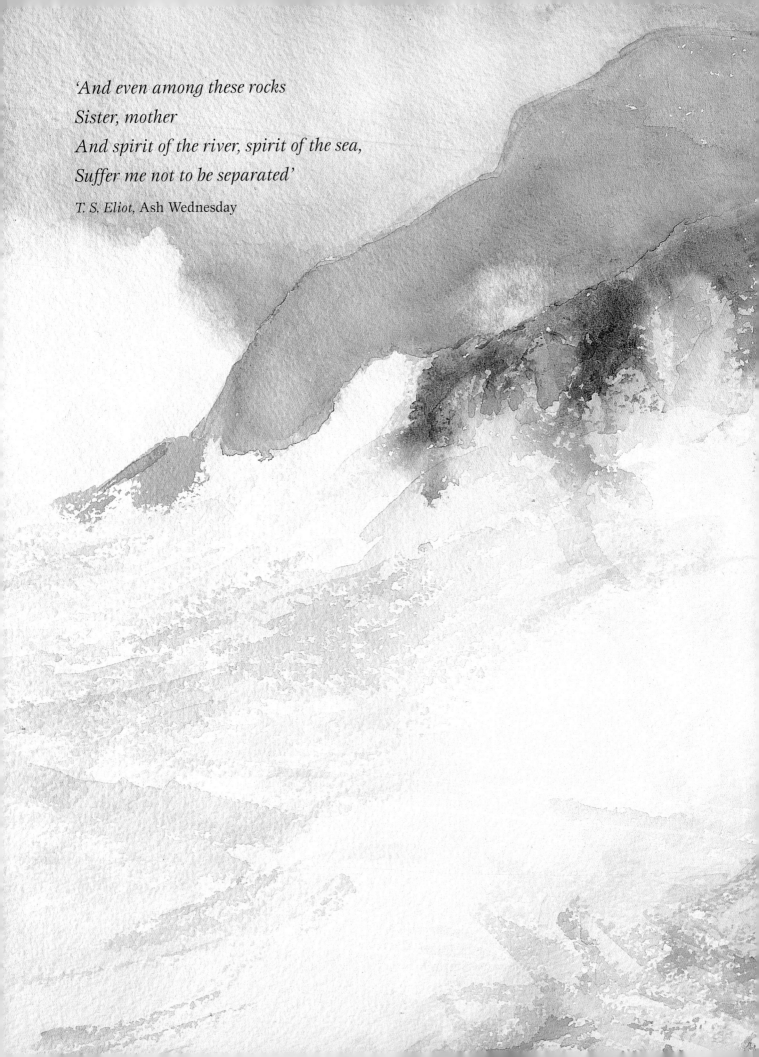

'And even among these rocks
Sister, mother
And spirit of the river, spirit of the sea,
Suffer me not to be separated'

T. S. *Eliot*, Ash Wednesday

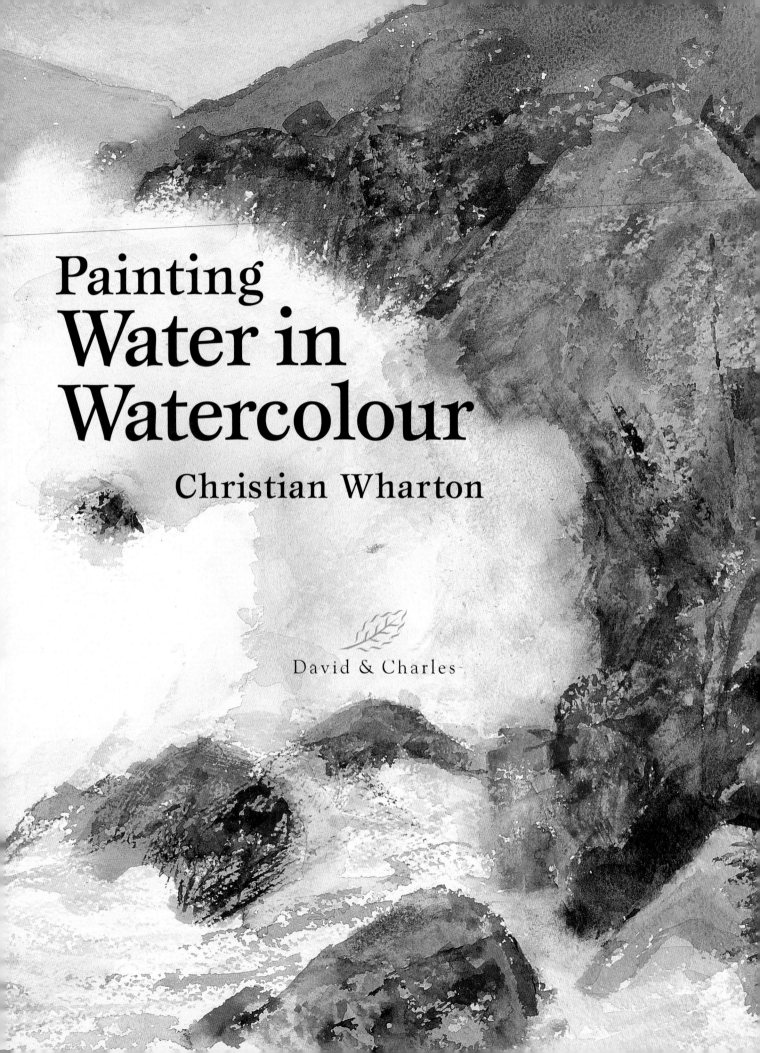

# Painting
# Water in
# Watercolour

## Christian Wharton

David & Charles

To Duncan

## A DAVID & CHARLES BOOK

First published in the UK in 2003

Distributed in North America
by F&W Publications, Inc.
4700 E. Galbraith Rd.
Cincinnati, OH 45236
1-800-289-0963

A catalogue record for this book is available from the
British Library.

ISBN 0 7153 1388 6 hardback
ISBN 0 7153 1638 9 paperback (USA only)

Printed in China by Lee Fung-Asco Printers Ltd
for David & Charles
Brunel House    Newton Abbot    Devon

Photography by George Taylor, Duncan Wherrett
and Clare Bates

Photograph p44: photographer unknown, *The Daily
Telegraph* Photograph p61 (bottom): John Sell Cotman
(1782–1842) *Greta Bridge, Durham* (British Museum,
London, UK/Bridgeman Art Library) Photograph p70 (left):
Claude Monet (1840–1926) *Water Lilies with Willows*
(Private Collection/Superstock) Photograph p70 (top
right): Claude Monet, *Water Lilies* (Neue Pinakothek,
Munich/Superstock)

Senior Editor: Freya Dangerfield
Project Editor: Ian Kearey
Art Editor: Sue Cleave
Layout: Lisa Forrester
Production: Kelly Smith

David & Charles books are available from all good
bookshops; alternatively you can contact our Orderline on
(0)1626 334555 or write to us at FREEPOST EX2 110,
David & Charles *Direct*, Newton Abbot, TQ12 4ZZ (no
stamp required UK mainland).

**Visit our website at www.davidandcharles.co.uk**

**The Author** Christian Wharton studied art in Paris and London after receiving an MA from
St Andrews University. For the last twenty years she has devoted herself to the study of water
in watercolour, has held four solo exhibitions in London, and has paintings in public and private
collections throughout the world. At present she lives in Skelmersdale in Lancashire.
Email address: cw@christianwharton.com
Website: www. christianwharton.com

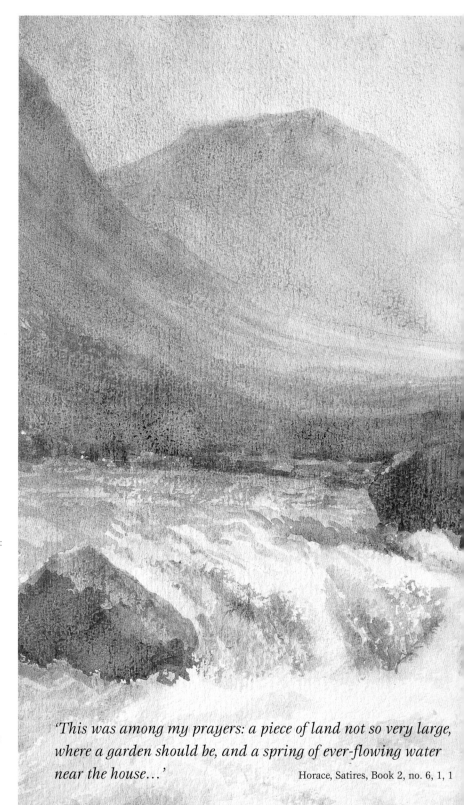

*'This was among my prayers: a piece of land not so very large,
where a garden should be, and a spring of ever-flowing water
near the house…'*

Horace, Satires, Book 2, no. 6, 1, 1

# Contents

# Two dogs, or, How I started painting water

No mystic visions in the night, nor any unseen voices prompted my involvement with water. The process was a haphazard one in which two dogs played a major part. In the summer of 1982, when I was living in a cottage on the Welsh bank of the River Monnow, I spent a lot of time playing with my Welsh terrier, Robbie. He loved to splash about in the shallows and although he wasn't really a swimmer, he could be induced to plunge in if you threw enough stones and made enough splashes.

My other dog, a German Pointer, had an entirely different relationship with water. His obsession with retrieving was intensified when it came to sticks thrown into deep water. He made a spectacular sight as be bounded after his prey, leaping with total abandon into the water with a great bellyflop and an almighty splash. What a subject for a painting!

But it turned out to be more difficult than I had imagined. It was difficult to sketch, as it all happened so quickly. When I used a camera, all I produced were very inadequate shots of the rear end of a blurred dog and some smudgy water – nothing like what my eyes had seen.

Blaming my ignorance of photography, I borrowed a better camera, bought a faster film and set up on the banks of a canal, with an assistant to throw the sticks on the opposite side.

The results were surprising and showed me things about the fundamentals of perception that it took years to understand. The shots were useless as far as I was concerned, but they were fascinating from a scientific point of view for what they showed about the actual process of the dog's jump into the water. German Pointers have deep chests and slim behinds. What my dog was actually doing was leaping about 60cm (2ft) up in the air, throwing his head back and, at the same time, clawing the air with his paws so that his front reared up and he entered the water vertically, bottom

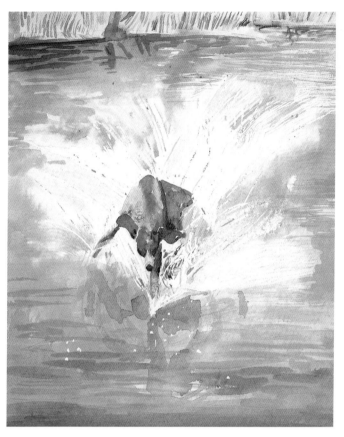

**SPLASHING DOG** 38 x 28cm (15 x 11in)
When I painted this, my only idea of painting a splash was to use some strokes of masking fluid and leave most of it white. I had no idea how to do it.

first. What was even more amazing was that at the point of contact there was very little splash. In fact there was hardly any splash at all until the dog was completely submerged. And then it all surged up.

It was a splendid illustration of the fact that what we see is so often an illusion – like the perception of racehorses galloping with their front and hind legs stretched out that was killed by Muybridge's nineteenth-century photographs.

But I just wanted to get on with my painting. I knew what the answer must be – that I would have to superimpose the image of a splash on the image of a leaping dog. I hardly knew how to begin. But if I wanted to

paint a splash, the thought occurred that a waterfall was a continuous splash and could provide the information I wanted. By this time, I was living in Lancashire with easy access to some of the best waterfalls in Britain. The more I painted waterfalls, the more I became obsessed with the subject. It took time to find out how to do it, but the process was blissful and fulfilling.

This book is about the process of painting water. It is an attempt to share with you the inordinate pleasure I feel when I am in the presence of moving water, as well as the pleasure of expressing it in paint. There is no point in your painting water unless you participate in this feeling of celebration.

I have read so many books on doing things that emphasize 'joy' as a prerequisite. ('Teach your baby to read' was one. I spent hours holding out flash cards to my toddler as she sat on her potty, trying to feel joy and not infinite boredom.) Unfortunately, it is not possible to manipulate emotions just because these are desirable. But fortunately, I am dealing with a subject which has universal appeal. Few people need to be told that they should be feeling happy when they are in the presence of moving water – it would be much harder if this was a book about the joys of painting landfill sites.

'Challenge' is the euphemism devised by the positive-thinking movement to circumvent the word 'problem'. I prefer straight talk – I cannot pretend that there are no problems with painting water in watercolour. But if you go about it in the right way, and with the right attitude from the start, these can be minimized.

And attitude, thought and feeling are the key to it all. They are much more important than technique. I hope you will be inspired to paint water, to enjoy doing so and, by doing this, to get even more pleasure from looking at it.

This book is for everyone who is interested in water, whether you want to paint it or not, and whether you are an absolute beginner or an accomplished artist. However, if you have never painted water before, even if you are raring to go, I hope that you will read the whole of this book before you start – because this will save you a lot of time finding out the things I have had to learn over the years.

**ROBBIE IN THE MONNOW** 38 x 28cm (15 x 11in)
This is my first painting of moving water. It is successful because the calligraphic treatment of the splash, done with masking fluid, is echoed in the curves of the ripples in the water, the tree trunks and even the bank – it expresses the dog's exuberance. But I didn't have the faintest idea about underwater pebbles.

> '… a sense sublime
>
> Of something far more deeply interfused,
>
> Whose dwelling is the sight of setting suns,
>
> And the round ocean and the living air,
>
> And the blue sky, and in the mind of man.'
>
> William Wordsworth,
> Lines Composed a Few Miles Above Tintern Abbey

# chapter 1
# The ecstasy and the anguish

Water has always played a special part in my life. I grew up on the banks of a great river and went to university by the sea. I have spent many hours watching waterfalls and Atlantic breakers crashing in on the West Coast of Ireland. I have always longed for a house with a stream in its garden. So why did it take over 20 years to discover this special affinity?

**VENICE** 56 x 76cm (22 x 30in)
The actual colours of Venice are rather dull, but here I used colour to evoke the richness, the romance and the dreaminess of the place. I used lots of overlaid washes and sponging until it felt right. There is also a touch of gold framing wax.

# Why paint water?

The reasons it took so long were commonsense, practical ones. Water is a difficult subject. It is not only always moving – evanescent – it changes even when it doesn't move, because of the light and the position of the sun. When it is most turbulent and thrilling to watch, there is least light to see it by and conditions are impossible for working outside. Much better to stick to still lifes – flowers, fruit and teapots remain static.

It has taken a very long time to realize that there is no difference in difficulty between still lifes and waterscapes. That difficulty resides entirely in the imagination. Furthermore, moving water is actually quite easy to paint in watercolour.

What we paint is life itself, and whether it is still or moving is immaterial. Because of this and because we are so intimately involved with it, it is quite fair to say that it is ourselves that we are painting. It is our spirit, recognizing ourselves in the spirit of the object we are looking at. The Chinese have a word for it, 'Chi', which sums this up. Chinese painters aim to express the whole spirit or life force in the object they are painting in a few simple brushstrokes.

We never paint apples or teapots in order to convince you that the object we are painting actually stands in front of you. That is *trompe l'oeil* painting, something that, although it is highly skilled, defies the purpose of art. Art is there to inspire by giving the essence of the subject, and it does this from the level of feeling. This is why, given the huge number of still-life painters, there is such a small proportion of good ones. It is much harder to do than it seems, for there are thousands of artists who can paint fruit and flowers well enough for greeting cards. Very few paint with the same degree of truth as Van Gogh. This quality of truth does not result from careful modelling, details, or brilliant *alla prima* technique. It is something that is more than the sum of the parts. And it is best to aim for that level of truth, without worrying too much about whether we can achieve it or not. It's just more rewarding and more fun that way.

## The importance of water

We live in an age when science has made huge strides in understanding the fundamental levels of matter. On these levels it is not possible to distinguish between moving and non-moving objects. Everything is moving. Everything is made up of tiny little pulsations of energy, and what seems to be there on the surface has as much real solidity as the pixels on a computer screen. Objects that have strongly contrasted qualities on the surface level of perception, have less on the cellular, even less on the molecular, and hardly any on the atomic and sub-atomic levels. All we are, really, are great clouds vapourizing into vague shapes before we disappear into the unified field.

When you think about these things, it makes painting water much easier. Water can be perceived to be moving on the surface level of life. It not only covers the largest part of the surface of our planet; we are made of it. It is basic to life. Because it is moving it is a visual form of the underlying energy, of which we are all made, along with the rest of the universe.

I believe (although there isn't space to elaborate on this here) that art exists to take the attention inward to these fundamental levels. This is why it inspires and uplifts, and why it gives so much pleasure and such a feeling of unity and reconciliation. Of course the image is also important, but any advice or instruction that is based purely on this is doomed to failure. Technique by itself is nothing without the feeling level.

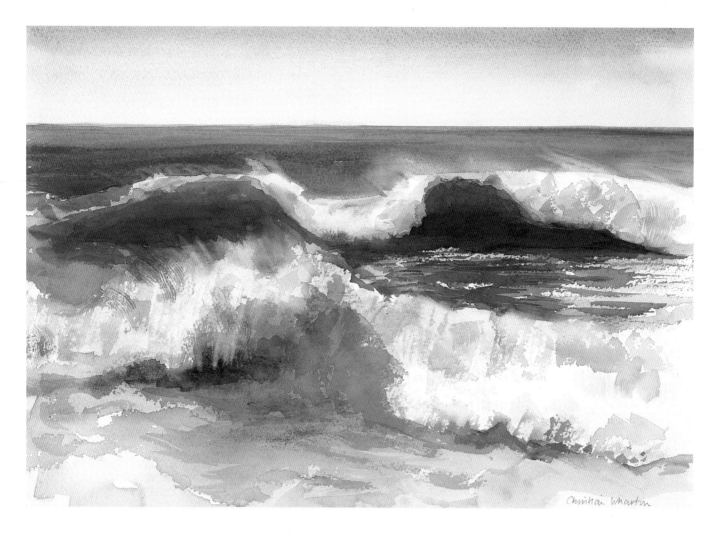

**CORNISH WAVES** 28 x 38cm (11 x 15in)
I painted this with soft washes to emphasize the gentle quality of the
rollers coming in on a heavy swell.

The difference between Rembrandt and Frans Hals sums this up. Hals was a superb painter, a master of light, texture and sparkle. But Rembrandt was a genius. What puts Rembrandt into this class is not his mastery of technique: it is the quality of his feeling, his compassion and love of humanity that his paintings express.

## Genius not required

You do not need to be a genius to have feelings of compassion. Nor do you need to be a genius to be able to express them in art. A young mother once showed me a drawing she had done of her sleeping child. It was a bad drawing in many ways – the perspective of the cot was incorrect and the features were in the wrong place. The pencil had been handled clumsily. And yet that drawing was full of feeling, full of love and innocence. You could tell that the mother had done it. I don't really understand how this was possible. How is it that a clumsily held pencil can express such

tenderness? It is part of the great mystery of art that it can and does. (If you don't believe this, try drawing a self-portrait with your left hand – or your right hand if you are left-handed. The marks will be clumsy, but the feeling will be there.)

It is the knowledge of this marvellous fact – that it is possible for feeling to emerge from the first beginnings – that gives us the courage to do it. Painting water is working from the heart. It is putting that feeling onto the paper. It is the act of expression of that love that we all have for our fundamental constituent. This is why we should do it and do it with confidence.

And when we paint it in watercolour we are using that fundamental constituent to help express itself. This is neat. It is also immensely blissful.

9

# Light

But there is something even more wonderful about it. A friend made an 'intelligent' comment that he felt quite proud about. (I know that he was proud of it because he repeated it several months later.) He said, 'You have mastered water. Now I would like to see you master light.' It set me thinking.

When you paint water you are painting light. For water has no colour and is practically invisible. What you are painting, when you paint it, is reflected light. The sea is not blue, unless the sky is. The magical blues, greens and golds shimmering in the Black Moss Pot disappear the moment the sun goes in. The whites of a waterfall or a breaking wave are delicate droplets like the filaments in a light bulb, gleaming with reflected light and, quite often, refracting it as well by producing tiny little splashes of pure spectrum colour. (I don't mean rainbows, although these also happen in certain places and under certain conditions.)

What we see when we look at water is either a reflection of the surroundings and the sky, or a slightly distorted version of what is underneath. Of course, there is some colour in water. Depending on the surrounding geology, it can be bluish, greenish or brown. In the Himalayas, the glacial streams are opaque – full of minerals from the glacier – and their whiteness increases as you get nearer their source. But the purer the water is, the less colour it has.

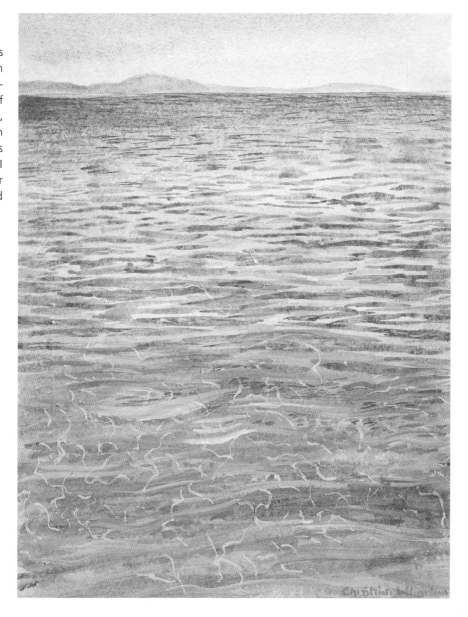

**SUTHERLAND WAVES**

38 x 28cm (15 x 11in)

These are really wavelets coming in on a calm summer's day. I was fascinated by the patterns of sunlight on the sand, which shone through increasingly as the waves approached the shore. I used masking fluid for the golden network and washes for the rest.

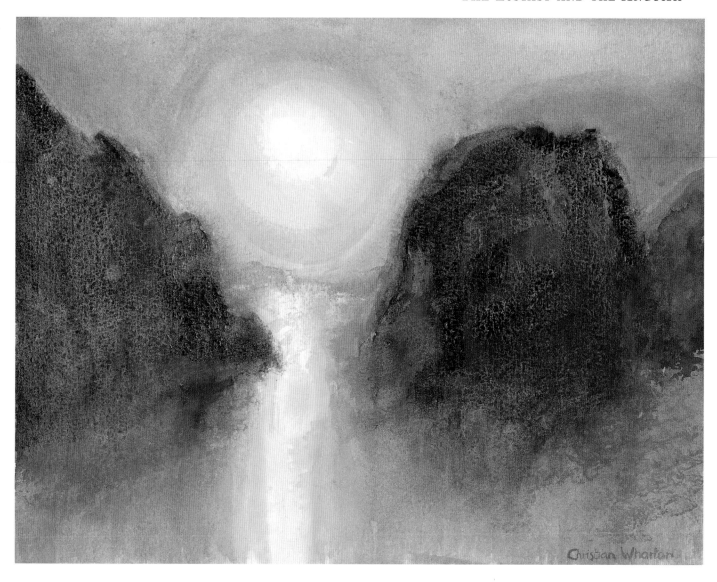

**SHETLAND SUNSET** 28 x 38cm (11 x 15in)
I painted this especially for this book, in order to illustrate the range of colour that is possible in watercolour, using a few colours I don't normally use, such as cadmium yellow pale and permanent rose, to get the richness of the sunset.

When we paint water, we are painting much more than our fundamental liquid constituent. We are painting light itself.

## The adventure of watercolour

Don't let anyone put you off watercolour by telling you that it is no good as a medium; that it is wishy-washy, just for old ladies and dilettantes; that it is impossible to get strong colours or make large paintings. This is nonsense, based on hearsay as well as bad experience of using poor materials, bad brushes and cheap, thin paper in childhood.

Watercolour is an economical medium. The colours, which, incidentally, are made from exactly the same pigments as oils, go a long way. I spend about £15 ($22) at most per year on paint. Brushes are more of an investment, but last a long time. Paper is probably the most expensive item.

There are practical reasons in favour of watercolour. It is clean, non-smelly and easy to use in a small space. You can eat off the same table you have worked on – I did for many years. It is so easy to wipe up and tidy afterwards. It dries quickly. The materials are light, which makes them much easier to take on holiday than oils. Perhaps this is why watercolour is associated with dilettantes – people who do not take it very seriously – but in reality it is for the adventurous; used to depict water, it gives something oil paint never can. Everyone should have this pleasure.

# Why watercolour?

Watercolour is absolutely the best medium for painting light because of its delicate transparency, its immediacy and freshness. It is magic to watch what happens as the colours blend on a wet surface or a rapidly scumbled brush expresses the vibrancy of shimmering colour in a pool. Or when a few touches of a dark tone suddenly transform white paper into a sheet of white water tumbling over a rock. All the time you are painting light. The brush dances in the rhythm of the swirling rapids. It is so economic, so immediate and so true. Because water moves fast, there is something profoundly satisfying about painting it fast. Sometimes, when I am painting, the brush seems to move in my hand all by itself – as though I am not controlling it any more. It is as though something is expressing itself through me. It is a good feeling.

Watercolour is the right medium for water because it is also an immensely flexible medium. There is a variety of techniques, ranging from fast to slow and from dry touches with a small brush to wet washes with a large one. It is also a pleasure to work slowly, to plan, to organize and to achieve effects that do not appear in the early stages.

There comes a moment when suddenly it is there. That morning with the sea swept up by a chill breeze, or that afternoon when the sunset caught the spray of a waterfall, transforming it into a pale apricot mist and giving me the feeling of being bathed in champagne. The painting has arrived at the moment of truth. It was easy and simple.

Alas, it is not always like this! I try not to classify my paintings as 'disasters', but some of them – well, to be honest, a good many of them – are 'learning experiences' and are torn up and recycled to be used on the reverse for colour experiments.

For it is a fact that watercolour is a harder medium to learn than oil paint. When you paint in oils, the

**PAINT DRYING LIGHT**
All of this painting was darker when it was wet.

colours stay on the canvas more or less as you have applied them. Watercolour is different. It moves all over the place, and it often dries to a lighter tone. The colours behave with distinct, individual characteristics. Some washes will dry smooth and flat, and some will make rather nasty, wriggly 'shorelines' of condensed pigment, just where you don't want them. Almost all washes will dry with a hard edge around

**HARD EDGES**
Watercolour paint dries with hard edges, especially when you use a lot of water.

12

**UNPREDICTABLE WASH MARKS**
Washes make interesting and completely unpredictable effects. The mark on the right was caused by the wash colliding with the edge of the paper and thrusting backwards like a breaking wave.

**COLOUR RUNS**
The 'hedge' on the skyline was entirely the result of paint from the hill running into the wash for the sky.

**PAPER TOO WET**
In this example, the paper was too wet to take any more paint – this was meant to be a boat on a lake!

them, which is fine if you want hard edges. But clouds, hills and rocks come without defined outlines. And although colours melt into each other delightfully when you apply them, it isn't always easy to get a soft edge just when you want it.

You take an enormous amount of care to keep washes (on a hill against the sky, for example) separate while they are drying, but somehow something tunnels through and an estuary or a tree begins to form on a skyline – and then, just as you are beginning to accept that you might like a tree on the skyline, it fades as it dries into a sad blotch.

Then there is the depressing moment when the paper gets too wet to take on any more colour and it just becomes a toneless splurge, which looks even worse when it dries (lighter of course) because the paper then warps and cockles into a thousand bumps and depressions.

## The problem of white

All the other problems are as nothing compared to the real headache of watercolour – it is impossible to paint white. Once you have colour down, it is impossible to make, for example, splashes of white spray over a rock.

There are white paints available – Chinese white is one – but the opaque chalky colour that they produce is nothing like the light that is reflected from the white of the paper. Watercolour paint is translucent. It helps to think of it as translucent layers, like layers of coloured tissue paper. Any white paint you use works against that translucency (not that it can't be used at all).

However, there is an answer to this problem, which I cover in more detail in Chapter 3. It depends on mind-set and organization, and is by no means as difficult as it might seem.

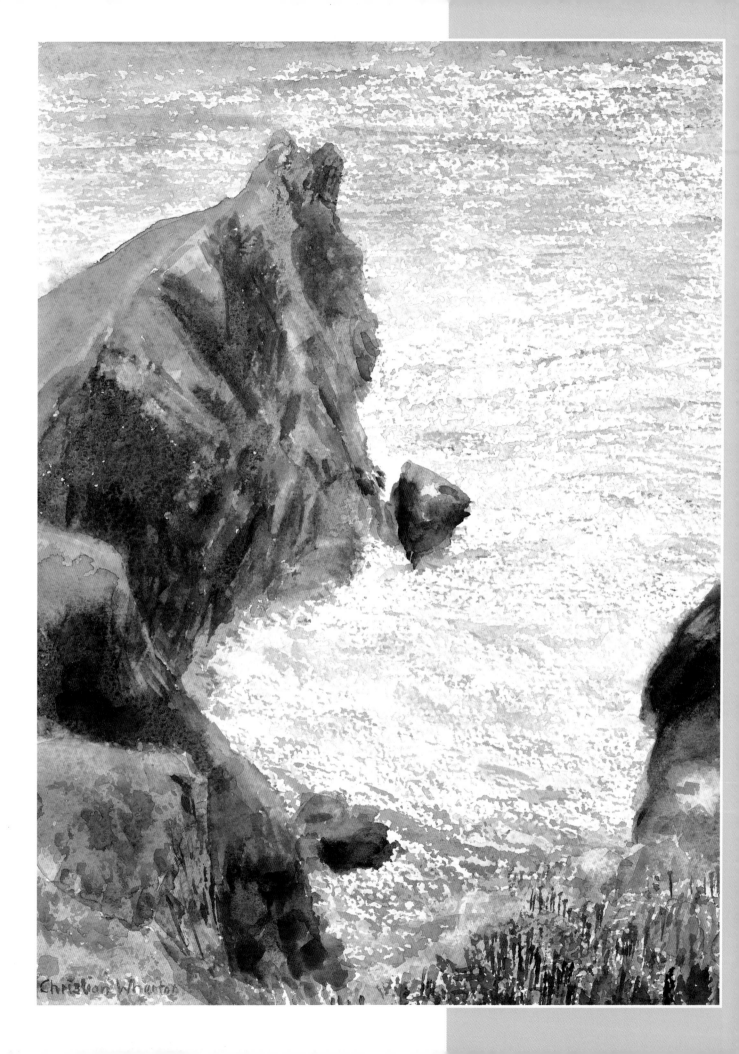

Christian Wharton

*'The water comes ashore,*

*And the people look at the sea.*

*They cannot look out far.*

*They cannot look in deep.*

*But when was that ever a bar*

*To any watch they keep?'*

*Robert Frost,* Neither Out Far Nor In Deep

# *chapter 2* Looking at water

A painting starts in the mind of the artist. This process of gestation can be long or short. Some of my paintings have taken over 30 years to produce. Before you paint water you need to look at it. You can't just start by saying, 'Today I am going to paint a waterfall,' as you could if you were going to paint three oranges and a pot of primulas. You need to look, observe and think long before you start work.

**THE NAB, LERWICK** 38 x 28cm (15 x 11in)
This great chunk of rock juts into the harbour at Lerwick and is one of Shetland's favourite viewing spots. I painted it on a dazzling day in early June. To capture the sparkle on the water, I dragged the flat of a square-ended brush fast across the paper. Undiluted cadmium red was used for the shadows on the rocks and phthalo green dropped in to make the darks more lively and luminous. The pinks in the foreground were done with a mixture of drybrush and light washes.

# Inner vision

I used to think that there were two kinds of painter: those who externalize an inner vision – expressionists, you could say – and those who express what is outside them – impressionists, in other words. Indeed, it seems like this with landscape painting. Landscape painters are the impressionists who, inspired by a view they have seen, decide to paint it. However, over the years the realization has gradually dawned that it isn't like this at all. The painting exists already inside you, at some deep level, and what happens when you see something that you want to paint is that you are recognizing this.

For me, seeing something that I want to paint is like meeting up with an old friend – there is this sense of recognition. I do not expect that you will accept this idea at once, because it sounds so unlike common, everyday reality. But then art is not common, everyday reality. Michelangelo said that the sculpture existed already in the block of marble – all he was doing was stripping off the layers that were concealing it. What he meant was that the idea of the sculpture was already there, finished inside his mind, which he transferred to the rock as he looked at it.

When I find something that I want to paint, the feeling nowadays really is like meeting someone I have already met. And when I look at the white paper as I am about to start work, sometimes the completed painting looks out at me.

You have to look long and hard at your subject before you can begin to paint it. I cannot emphasize enough the importance of this observation stage in the process of starting a painting.

**POOL, LONGSLEDDALE** 56 x 76cm (22 x 30in)
This beck has green-tinted water and is one of my favourites. I used a lot of diagonal movement in the rocks at the back and in the foreground. This contrasts with the curves of the water. I used bright touches of colour to lead the eye around the rocks which frame the pool. I wanted to celebrate the energy and power in this deep pool and the marvellous patterns made by the little strands of foam.

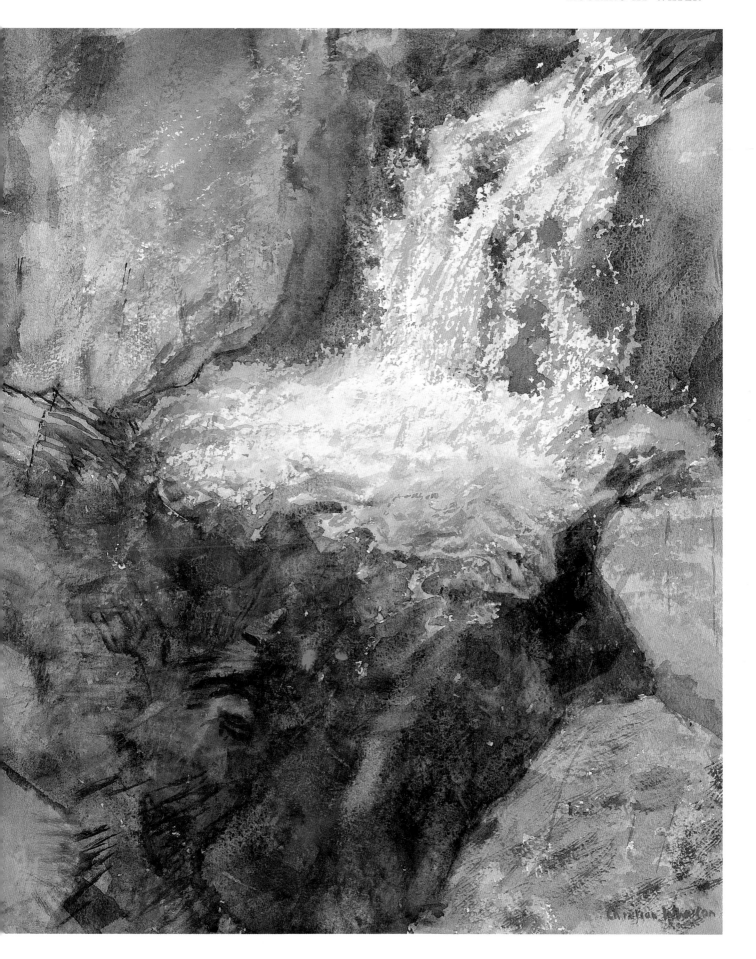

## Technique and feeling

Looking, feeling and thinking are more important than technique. This is not to say that technique, which is a way of doing less in order to accomplish more, is not important in watercolour. There is a greater range of techniques than in oils, and a lot to be learned. But technique by itself also has the unfortunate result of constricting the vision. I have encountered many students who have learned, from books or evening classes, 'how to do' skies, trees, flowers, Chinese brushwork and so on. However, the quality of feeling is entirely absent from their work, which has a dull, stereotyped look – a quality that also exists in the work of many professional watercolourists.

If you want to get it right – and it is so much more enjoyable if you do – then you have to go out there, spend time with your subject and look and look again.

But do we actually see what we are looking at, and do we actually paint what we see? And is what we see what is actually happening in front of us? I have already touched on this question in the Introduction in my story about the German Pointer. What we see is rarely the whole story of what is happening, but what we paint has to be a sort of encapsulation of what is out there. It has to be true to itself. But it doesn't always have to be the literal truth of what is there.

## Using your eyes

What happens when you look at a waterfall? The eye is a delicate and complicated organ. You can move your eye down the falling water at the same speed as it travels, which means that you can, in effect, 'freeze' the movement, in the same way as a camera. But the really amazing and wonderful thing is that at the same time as this is happening, you can also see the motion and energy of the water. Try it next time you look at a waterfall. Your eye is able to do two things at once – it can show both the flurry and blur of the motion and the detail of the 'frozen' image. (This is because the eye is in fact never still. It makes tiny little, jerky movements all the time.)

There is a fashion at the moment for photographers to take art shots of waterfalls with a long exposure.

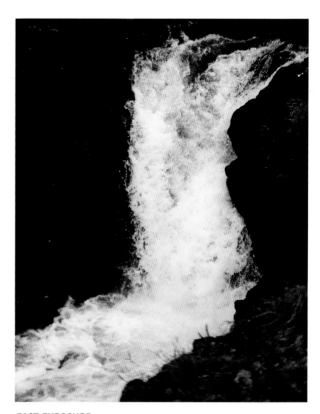

**FAST EXPOSURE**
Reference photograph of Skelwith Force taken with a fast exposure – the detail of the water is clear.

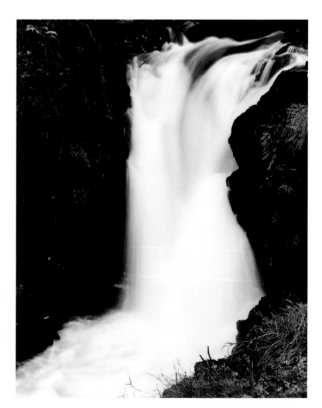

**SLOW EXPOSURE**
Reference photograph of the same view above, taken with a long exposure. The water comes out fluffy, but it does give some sense of the speed of the movement.

This results in what to me looks like long streams of tulle and not water at all. In a painting you have to be able to suggest rapidly moving water without freezing it and without making it look like tulle.

## On and off location

Unless you are fortunate enough to live in a house that overlooks water – a lake, the sea or even a waterfall – you will have to come to terms with the fact that painting water in watercolour is not something that you can do on-site. The French Impressionists were able to paint outside, but they lived in a charitable climate. Watercolour is a complicated medium with a range of techniques that means that it has to be organized in the studio. You are probably familiar with the term *alla prima*, which means getting the end effect in the first stroke. I would really love it if I could do this – it would be so economical – but it is just not possible. Adjacent washes begin to run together, and it is impossible to put down more paint when the paper is completely wet. And you miss out on the possibilities of superimposed washes, which can only be done when the first layer is dry.

Painting on-site is a good way of making notes, but complications occur when you want to use a lot of water. You cannot sit in front of an easel or with a board propped up on your knee, as the paint will run. The painting has to be done on the flat. So *alla prima* painting is really only useful for small studies of water.

There are two preliminary stages in the making of a painting of water. The first one is looking at it and getting the feel of it, the second is preserving your impression to bring back to the studio.

## You and your subject

Time spent by water is never wasted. (Perhaps I am biased about this, but it is good for the health after all. The negative ions that waterfalls produce in abundance help to clean our lungs and refresh and energize us, reversing the effect of the positive ions put out by television and computer screens.) If you spend some time with that waterfall, river or shore, you will find that certain parts appeal to you more than others, and

**SKETCH OF TREES**
I used the negative shapes to define the outlines of the trunks and branches and the shapes of the foliage, and made my pencil marks suggest the movement in the tree.

as time goes on you will find that you can choose more quickly what is right for you. Try looking at it from different angles, or framing it by making a rough rectangle with your hands. Or just sit and watch it with your eyes half-closed.

There has to be some sort of relationship between you and your subject. Never force yourself to take on something just because it is there and you can't be bothered to look for something else. I waited for a year to see a pool on the River Croe in Scotland. I saw it first on a day of swirling horizontal rain and deep dank mist. There was nothing there, only dark brown rushing water – but somehow it spoke to me. I returned a year later, and found that in sunlight it surpassed my expectations. On the other hand, I have travelled many miles to see famous waterfalls, only to find when I got there that they gave me nothing. There is one in Glencoe that is so famous it even has a Highlander in full regalia, complete with bagpipe, waiting to be photographed (and paid) in front of it. I couldn't do it – but climbing up above it for

about 20m (65ft) I found a much smaller waterfall, which had all the things I wanted, and I have drawn and painted it many times.

It might be that you find yourself attracted to some small part of a scene, some little detail of water, or you may feel inspired by some large, epic scene. I am drawn to these large ones. I would like to paint Niagara, but feel constricted by its size. The biggest waterfall in England is High Force, so I have made do with that. The English equivalent of Niagara, which is in County Durham, is the spot where the River Tees plunges over a 10m (12ft) cliff. Puny by Niagara standards, it is good enough for me.

It doesn't really matter what sort of waterfall, river, stream, pool or waves particularly appeal to you. But it does matter that you have some feeling for it. It is a simple matter of that overused word 'love' – which may not come at first sight.

**LEAVES FROM SKETCHBOOKS**

# Gathering information

The next stage is the process of taking the information that you need to the studio. You do this in several ways – thinking about it, sketching, making notes and finally by using a camera.

When you have found a scene that you particularly want to paint, then you have to think about it in a more organized way. This is the beginning of composition – deciding, for example, whether it is going to be portrait or landscape mode, or maybe something entirely different, square or round, or even elliptical. At this stage you do not need to think very much about composition (this is discussed later), but it is good to decide on the basic format. You can look through a sort of rectanglur aperture you can make with the hands, to help decide. And of course, the viewfinder of a camera is also very helpful for this.

It is very important to sketch – drawing helps you to look and to fix what you have seen in the memory. I am always daunted when I try to sketch a waterfall. The materials seem utterly wrong for the subject – it is so difficult to express streams of white light flowing over dark rocks with a black pencil on white paper. I know I should be paying careful attention to the rocks and the bits in between the strands of the water, but my fingers just want to express the dynamics of the flow, and if I allow them to do this all I end up with is a messy drawing of something that looks rather like untidy black hair splaying out over white rocks.

But drawing is important not only because it helps to fix the scene in your memory. It makes you look and find out what is actually happening. You should not worry too much about the final effect, because quite a bad drawing can help you to remember and understand the scene you are painting.

**POOL ON THE CROE** 76 x 56cm (30 x 22in)
This is a subject I am particularly fond of – the transition from the surface to the floor of a pool. In this case it was particularly beautiful because of all the varied colours in the stones in the foreground. It took very careful tonal adjustment to get the tones on the ripples and the rocks and stones underneath. I did a lot of softening with a sponge and a cotton bud to get rid of hard edges, and used pure colours to suggest the brilliance of the stones – magenta, cadmium red and yellow.

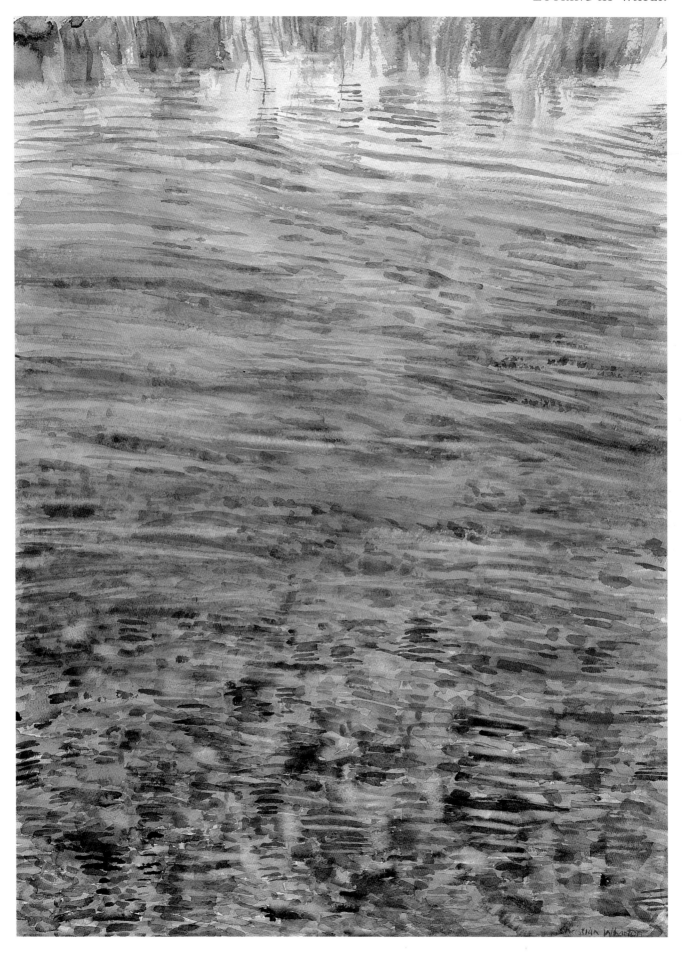

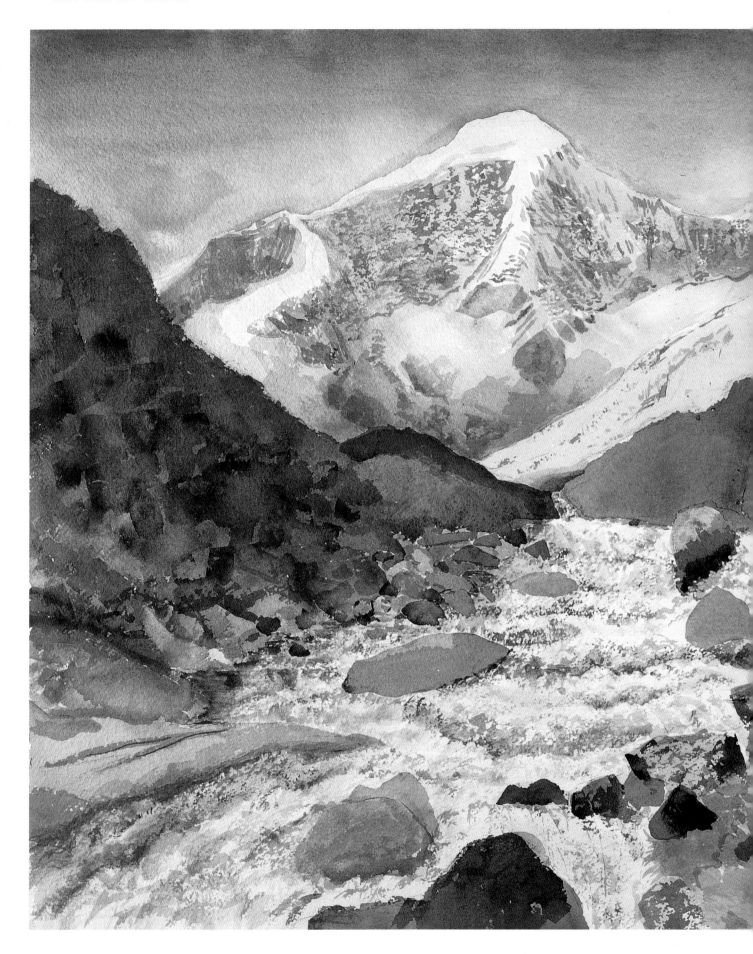

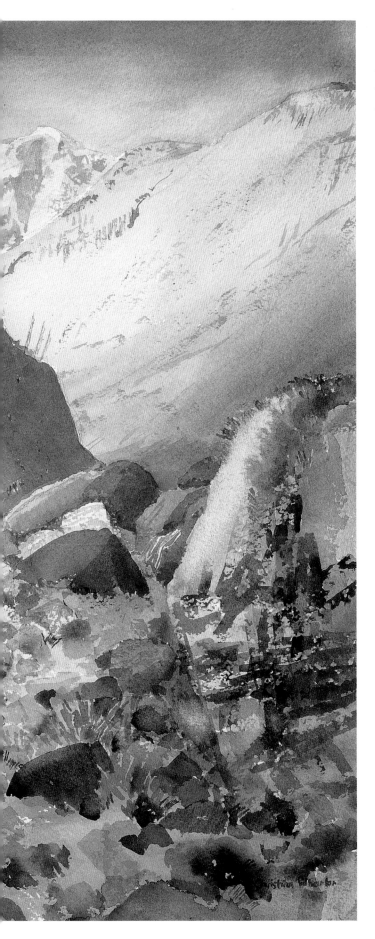

## The camera

Many artists use a camera to help them record and paint landscapes. It doesn't entirely replace the pencil, but it is a valuable tool; if you look at it like this, it will help to aid your memory. But it is important not to look on a photograph as something that contains more than your vision and your memory combined. You can never make a photograph into a painting. If you do that, then you are making the photograph into a substitute for your own vision – making it superior to what you saw and are remembering. In reality it is only a guide, like your on-site sketches and notes, to what you saw and want to express.

The camera is very good at some things, like the tone values in falling water and various details. But it has one big defect as far as waterfalls are concerned (though less so for rivers and pools) – that you need two different exposures: one for the banks at the side, and one for the white water. White water gives off so much light that if you expose on the water, the rocks at the side are underexposed and come out much too black. On the other hand, if you expose on the rocks, the water will be overexposed and too white. The answer to this problem is fairly simple, since you are not taking photos for a competition or public showing. Take several shots, some with the rocks in the centre and some with the falling water. Then you get some idea of what the rocks are like (see page 24).

There is another big defect with the camera, although this applies more to general landscapes than to waterfalls. When the eye looks at a scene it always makes the dominant feature larger. If there is a hill on the horizon, for example, the eye will see it larger. But in a photograph it will come up as a mere pimple, which is in reality how it is. But artists have to paint it as it appears to the eye.

**JHOMOLHARI FROM THE BASE CAMP** 56 x 76cm (22 x 30in)
When I saw this scene it was lit up by the late afternoon sun, which was catching the peak and turning the hill behind the ruined fort a pale, goldish brown. Everything in the foreground was in shadow and cold. I composed it from two angles so that the peak was in the right place over the dark hill and the water. All the whites were done with reserved white paper.

The dominant feature in the picture is usually what made you want to paint it, so sometimes you may find that in a photograph it doesn't look quite so significant. You have to remember that your vision and your memory are correct – not what the camera sees.

## Working with photographs

You can go further than this. You can change what both you and the camera saw on-site, to help your viewer to see and understand better. You can, for example, get rid of obstructing branches and even remove the whole tree if it is in your way. You can also combine features from more than one photograph because what you are trying to do is to get a distillation of the whole scene.

I painted a view in Bhutan of Jhomolhari (see pages 22–3), which everyone who has been there says is just like it, but I actually used about three different photographs from different vantage points. The painting of a chorten (a Buddhist monument – always solid, a little like an obelisk) by a stream, opposite, was a delight to make. The chorten actually was just by a bridge over a stream, but I used a stream further up the valley that had much clearer and brighter water.

I have found that some photographs are better than others at containing the information that can be made

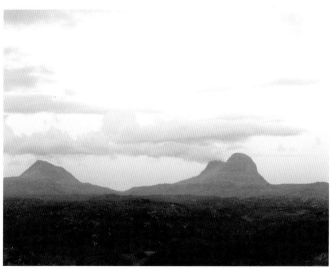

**DIMINISHING THE DOMINANT FEATURES**
Two mountains in Sutherland, Scotland – Canispe and Suilven. They dominate the landscape, but the camera makes them much smaller (unless you have a really good zoom lens, that is).

into a painting – not always the ones you would expect. I left a whole series of photos unused for several years because they didn't seem to say anything to me about what the scene meant when I saw it first. But when I started using them, I found that with what I had inside my head I could produce what I wanted.

This is why it is important to sketch and even to make written notes about what the scene meant for you. The camera is a useful tool, but shots are not to be taken too literally.

**DETAIL OF BANK AT SKELWITH FORCE**
This photo shows the actual tone of the banks on the left-hand side of the waterfall. In the first two pictures I took of this waterfall (see page 18) the banks were too dark.

**CHORTEN BY A STREAM, BHUTAN** 76 x 56cm (30 x 22in)
I composed this picture very carefully, using a photo of a different stream from the one which was actually near the chorten, in order to convey the strong light and richness of the colour in Bhutan. I used lots of delicate brushstrokes for the water in the foreground.

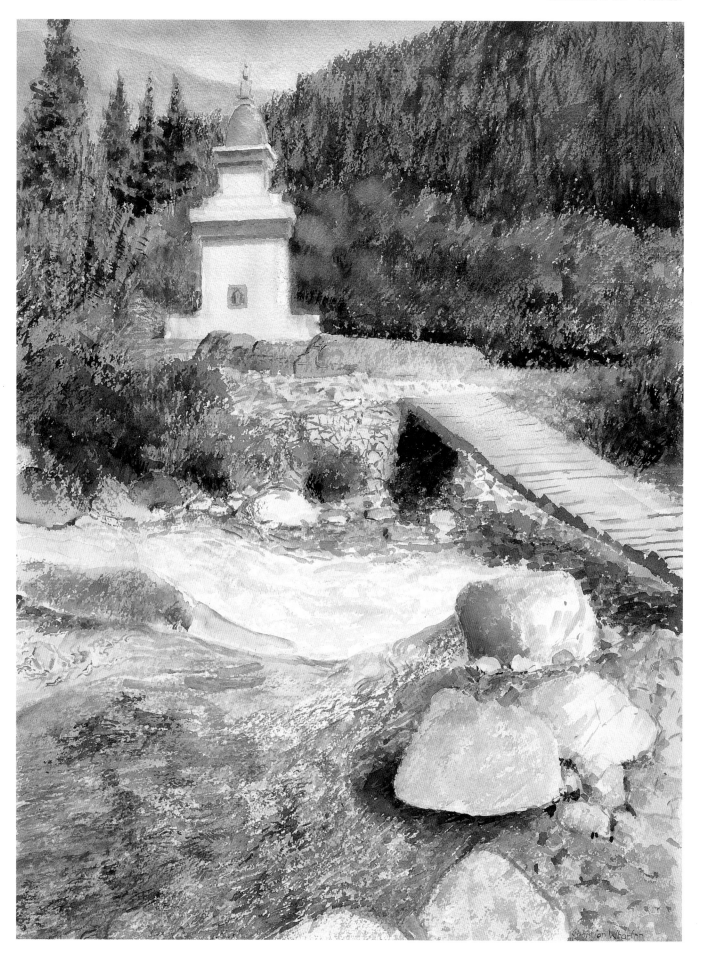

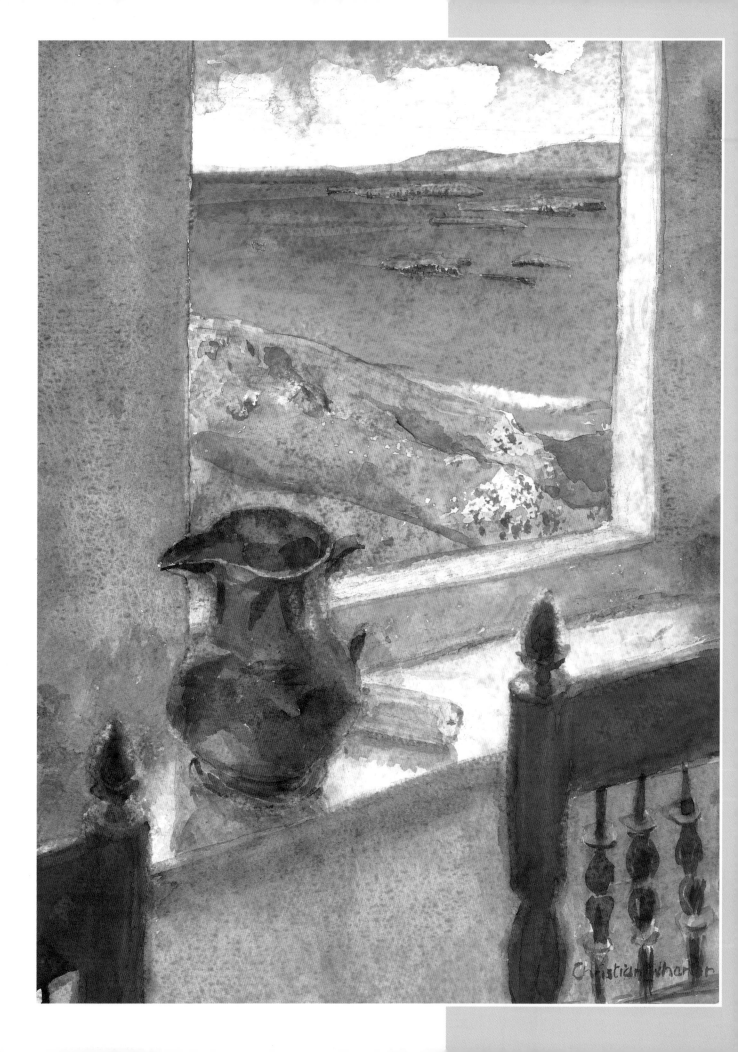

*'"On this Coast of Coromandel,*

*"Shrimps and watercressses grow,*

*"Prawns are plentiful and cheap,"*

*Said the Yonghy-Bonghy-Bò.*

*"You shall have my Chairs and candle,*

*"And my jug without a handle! –*

*"Gaze upon the rolling deep*

*"(Fish is plentiful and cheap)*

*"As the sea, my love is deep!"*

*Said the Yonghy-Bonghy-Bò…'*

*Edward Lear*, The Courtship of the Yonghy-Bonghy-Bò

# *chapter 3* Materials and methods

As a general rule, the more you pay for paints, paper and brushes, the further they will go and the more satisfaction they will provide.

**TOWARDS THE SUNSET ISLES OF BOSHEN** 38 x 28cm (15 x 11in)
I painted the chairs and jug with as much colour on the brush as possible, and as quickly as possible, without fussing too much about details. I then went round the whole painting with a sponge and a cotton bud dipped in water to soften the edges and to give the whole thing a hazy look.

# Materials

## Sketching equipment

Before you get anything else, you should have sketchbooks. A4 and A5 are good sizes – the smaller A5 will fit into a large pocket, along with pencils, crayons and/or oil-based pastels for making colour notes. The paper should be good-quality cartridge or drawing.

An A4 sketchbook with 200gsm (100lb) Rough watercolour paper is also necessary. (300gsm/140lb) is better, but more expensive.) This is for experiments with colour, as so much of watercolour painting is the result of your own discoveries – you have to try out alternative techniques for yourself and find out how they work with different colours. You should make notes on the paper about how the different effects have been achieved.

You should also have a camera. I have a single lens reflex one, which is quite heavy but very useful for taking shots in poor light. Otherwise I use a small automatic with a zoom lens, which seems to work for most of my needs.

**MATERIALS FOR GATHERING IMAGES**
Sketchbooks, camera, small box of watercolours, water container, pastels, paintbrush, pen and pencil.

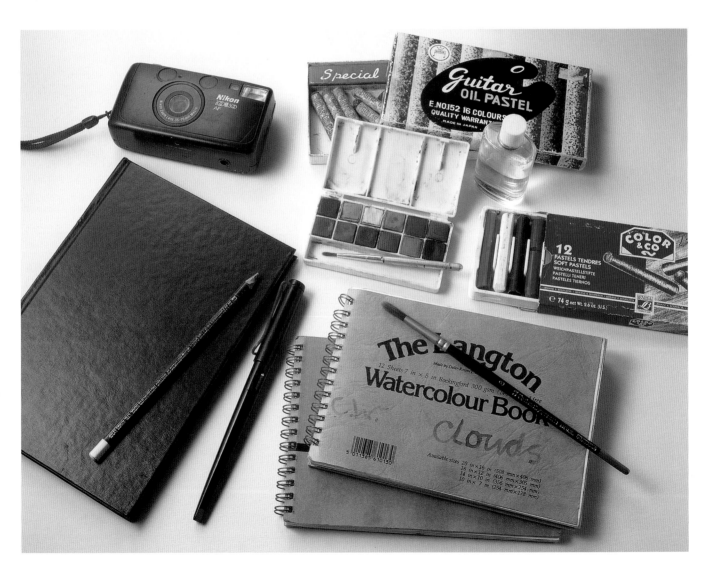

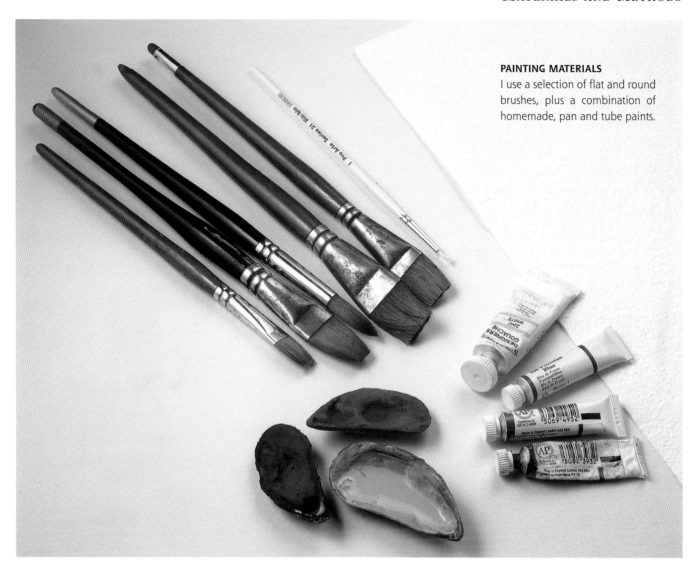

**PAINTING MATERIALS**
I use a selection of flat and round brushes, plus a combination of homemade, pan and tube paints.

## Brushes

For many years I believed that sable brushes were the only possible ones. They are indeed excellent, but wear out quickly, and I have become a convert to synthetic Prolene, which lasts much longer and works very well. A size 12 round Prolene brush is good not only for washes and large marks, but for small, delicate touches with almost dry paint. This is because the bristles form a really good, fine point, so you don't need a tiny brush for signatures.

Square brushes have a variety of functions. They are good for wetting, for washes and for large quantities of very wet paint. You can also use them for drybrush work with either the flat or the side, and you can use the ends for making little repeated lines, like the lines of reflections of trees. It is a good idea to experiment in your notebook and find out for yourself the range of marks your brushes can make.

The only other brushes you need are if you are going to use masking fluid, in which case you will want some cheap, disposable pointed brushes.

## Paper

There is no escape from the fact that paper should be good quality. Heavy paper takes a lot of punishment, can be wetted over and over again, and allows for a lot of correction. It doesn't need to be too heavy. 300gsm (140lb) is about right, and the sort I recommend is Rough-textured Fabriano Artistico. You can use a lighter paper for sketching, but it should not be much lighter than 250gsm (120lb). Although I recommend these papers, I mostly use Fabriano Esportazione 315gsm (150lb) Rough, which is a superb paper, but perhaps a bit expensive for beginners. Using a paper this heavy means that I don't stretch it, as it pulls away

29

from the tape. Although it warps and cockles a bit when wet, this never seems to get in the way of the painting, and it dries flat.

Of the three surfaces available – hot-pressed (HP or smooth), cold-pressed (CP or NOT – not quite so smooth), and Rough – I prefer Rough. You will understand why when you start to paint rapidly moving water. The bumps and depressions do most of the work for you. You can get several colours on at once by combining the different techniques, and by using a flat brush on its side you can create textures.

## Accessories

The other things you need are mostly self-explanatory – containers, saucers, palettes, sponges, pencils, pastels erasers, cotton buds and paper tissues. Jam jars can be used for both storage and water; if you use lots of small ones, the water becomes coloured and you have a ready-mixed wash, which saves a lot of time.

**EXTRAS AND ACCESSORIES**
Palettes, sponges, low-tack masking tape, pencils, masking fluid, glass jar, kitchen roll, cotton buds, toothbrush and eraser.

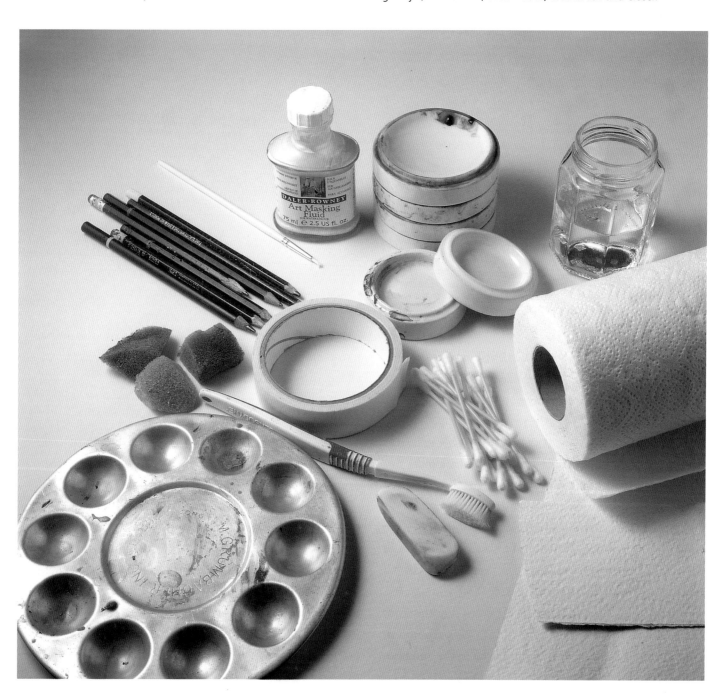

# Colour

Colour theory is outside the scope of this book. But it is worth remembering the basic fact that colour comes from the pure colour of the spectrum – the seven colours of the rainbow: red, orange, yellow, green, blue, indigo, violet.

The wonderful thing about the rainbow is the way in which all the colours blend effortlessly into each other. This is even more apparent if you take them out of the rainbow and arrange them in a circle or a wheel. If you can always think of them like this, you will have no difficulty in mixing or finding harmonious colours.

Pure colour only exists as light. When you come down to earth you have pigments, which are a very rough and crude substitute. The difference between pigments and colour is that white light contains all the colours, black being the opposite of colour – but in pigments it is black, or rather very dark brown, which contains all the pigments. This is because they all contain an element of grey known as 'saturation'. So when you are dealing with light, the three primary colours are magenta, cyan (a very bright blue-green) and yellow, but when you are dealing with paint, they are red, blue and yellow. Even then, the pigments are not really 'true', i.e. they don't really come from the exact middle of the band of gradating colour that you see on the spectrum. So, although in theory you can mix any colour from the three primaries, in practice your palette will be very dull and restricted when you attempt to do so. (Having said that, trying to do so is an excellent way of learning how to mix colours.)

I thought this until I discovered liquid watercolours. These colours come in small bottles, usually with an eye dropper. They have advantages in that they do not behave like watercolour by drying with hard edges, and the colours themselves are so pure and close to the spectrum that you can mix all hues from just three colours. But, alas, they are not permanent and fade very fast. They are for graphic designers. Don't get caught!

This introduction is just to explain why I am recommending particular paint colours. For economy and for efficiency you need the three primary colours, but since each has a bias towards one or the other of its neighbours in the colour wheel, you need two of each, so you end up not with yellow, red and blue, but with green-yellow, orange-yellow, orange-red, purple-red, purple-blue and green-blue.

This scheme is slightly too orderly for the vagaries of watercolour because of the variations in behaviour of the different colours.

## Choosing a palette of colours

Every artist has their own selection, and mine is as follows: cadmium yellow, cadmium red, magenta, ultramarine, phthalo blue and phthalo green. These are the colours that I find work best for waterscapes, but this is not to claim that they actually are the best – you might find another set which works better for you.

Cadmium yellow is an orange-yellow, and cadmium red is an orange-red, but I don't have a great need for green-biased yellow. Magenta is a fairly new addition to my range – it makes stunning purples, but also wonderful light reds when mixed with cadmium yellow. It also livens up the dark colours in rocks and makes very good greys and blacks when mixed with phthalo green. I didn't use it until I began to see these colours in the landscape before my eyes.

Ultramarine is a wonderful purple-biased blue – a very strong colour, good for darks as well as for heavy, stormy skies. It is made from a heavy pigment, which means that it sinks well into the hollows of Rough

*Cadmium yellow*

*Cadmium red*

*Magenta*

*Ultramarine*

*Phthalo blue*

*Phthalo green*

paper, giving a good texture. It is difficult to lay down in a wash, as it almost always makes a watermark when it dries.

Green-biased phthalo blue is almost the opposite. It is also a very strong colour, but the pigment is not so heavy. It is good for skies and goes on much more smoothly than ultramarine. When mixed with ultramarine it produces a magnificent blue for seas or pools and also, thinned down, for northern skies.

Phthalo green is a dangerous colour. I love it, but a little goes a long way. It makes a good green for landscapes if quietened with some cadmium yellow and a hint of cadmium red, but I use it mainly for dark colours. Mixed with cadmium red, it makes the best black. But the two colours – like my two cats – hate each other and try to separate whenever you mix them, which can lead to interesting effects if applied very thickly with lots of water. Put on over ultramarine blue, phthalo green can have the effect of pushing the ultramarine pigment into the hollows of the paper, producing a wonderful shimmering effect of two colours on at the same time. It can revive muddy colour and can produce all sorts of interesting effects when dropped in over paint with heavy pigment. Its only defect is that once it is on, it is hard to take off.

There is an optional extra for painting white, or rather for painting very small areas of white, or light tones over dark. It is not watercolour, in the strictest sense, although it is water-based. This is zinc white designers gouache.

## The great debate – pans or tubes?

I prefer pans because it is easier to make washes by holding them over a container of water and brushing them down with a wet brush. If you make a wash with a squirt from a tube, you tend to waste a bit of paint because it gets covered with water and is not all mixed in. I also suspect that tubes have more additives in them to give them a longer shelf life, and additives are not a very good thing. On the other hand, tubes are easier to transport, as pans tend to stick to the underside of any container they come into contact with (a saucer, for example), and you can spend hours searching for them. But when it comes to making a small stroke with the point of the brush, you get a better texture with a brush stroked over a pan of caked paint than you do from a piece of tubed paint.

A sensible compromise is to use pans for the colours you use most and tubes for the colours you use more sparingly, like phthalo green, magenta and white gouache.

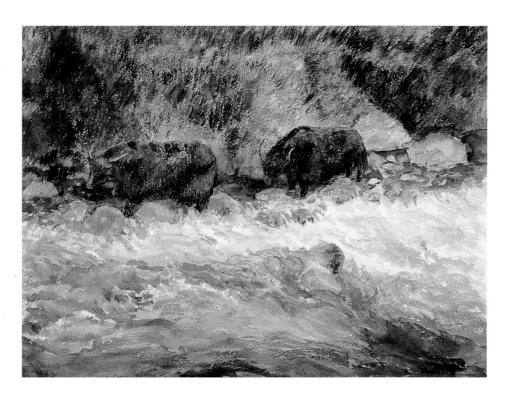

**TWO YAKS CROSSING A STREAM**
56 x 76cm (22 x 30in)
There were very strong contrasts of dark and light as the sun filtered through the trees. I used a dry brush for the animals and most of the trees in the background, and switched to wetter paint for the water in the foreground.

# *Making colours*

Making your own colour is a great pleasure, but it only makes sense if painting is not a spare-time activity. Mixing your own colours does give you an idea about what actually happens when you lay down a wash, and why the colours behave differently.

Basically, watercolour consists of powdered pigment mixed into a paste with a medium made from distilled water, gum arabic, glycerine and honey (1 part gum arabic dissolved in 7 parts of water and strained through a cloth, to this add 4 parts of honey and a few drops of glycerine). Gum arabic helps the colour to stick to the paper; and glycerine and honey help to preserve it. Some artists add ox gall to the mixture to help it spread, but I don't. Mix the paint on a hard slab – glass, marble or polished slate.

Mussel shells are the traditional way to store paint. But I have to say that the paint I make does not keep as well as the commercial versions – it eventually goes very hard and becomes unusable. This is why I only make ultramarine and the two cadmiums nowadays – I use more of them, and even if I didn't, they seem to last. However, if the paints do dry out, this does not mean that you have to throw them away at this point, because you can always regrind the hard cakes back into a powder and start again.

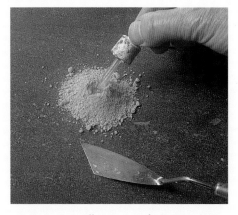

1 Form a small amount of pigment into a small volcano with a crater and drop some medium into the hollow. Mix it into a paste, the texture of thin, lumpy cream, with the palette knife.

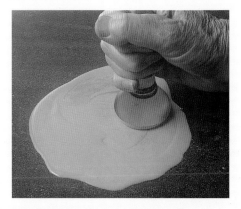

2 Grind the cream with the muller. The paint gradually spreads over the surface of the slab until you can make a figure of eight.

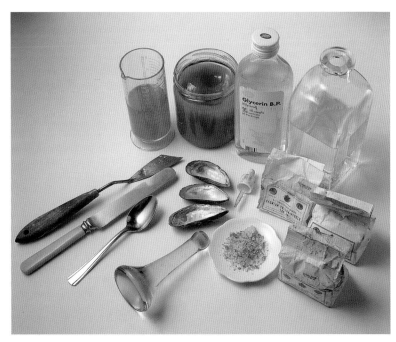

**MATERIALS AND TOOLS FOR MAKING PAINT**
Clockwise from beaker at top left: medium, honey, glycerine, distilled water, powdered pigments, gum Arabic, eye dropper, glass muller, mussel shells, spoon, knife and palette knife.

3 When the paint is thick, matt and glossy, scrape it off with the palette knife and put it into mussel shells.

# Techniques

In the next few pages I show some basic techniques. I cannot pretend that this will be a comprehensive list of all possible techniques, but these are the ones that I find work best for me. If you have never done any watercolour painting before, I would suggest that you practise these techniques – it is worth becoming familiar with them.

As mentioned before, techniques, being a way of doing less and accomplishing more, are important in watercolour, as well as being fun. However, I cannot emphasize enough that they are a means to an end and not an end in themselves. They are no substitute for patient observation, thought and feeling.

There is an infinite number of ways in which the various techniques can be combined. It is quite likely that you will find something I have never managed to do. This is why it is so important that you keep your experiments in a notebook and write down how you achieved each effect. I experiment all the time, using the backs of torn-up paintings. I find it a relief from painting, or sometimes it just fills in the time while I am waiting for a particular section to dry.

## Techniques on dry paper

**Washes – areas of plain colour evenly applied.**
The traditional method is to use a gently sloping surface and to dry out the accumulation of wash that runs down to the lowest edge, with a squeezed-out brush.

**THINLY APPLIED WASHES ON DRY PAPER**
Each wash, of cadmium yellow, magenta and phthalo green, was applied on a slope, and the surplus paint which fell to the base of each triangle was picked up with a squeezed-out brush.

**Superimposed washes.** Allow the paint to dry between applications. You can use a hairdryer to help it dry, but beware – on heavy surfaces sometimes the paper remains damp underneath the dried surface and the paint will leach underneath, which produces most interesting – if unwanted – effects.

**SUPERIMPOSED WASHES**
The same technique was used as for the thinly applied washes below left, and each wash was allowed to dry out before the next one was imposed.

**Drybrush – using thicker paint and less water.**
You get many different effects from different parts of the brush. This is a very useful technique and worth experimenting with. Keep your drybrush experiments for future reference.

**DRYBRUSH MARKS**

## Techniques on wet paper

The paper should be lightly wetted with a damp sponge. This is also something to try out and practise with. It is impossible to give formulas, as so much depends on the paper and even the dampness in the atmosphere. You have to learn through practice.

Dropped in colour travels effortlessly over the surface. It is a great delight to watch the water and the paint working for you – except for when it is something that you do not want.

**DRYBRUSH MARKS ON HEAVIER PAPER WITH
SQUARE-ENDED BRUSH**

**PAINT EFFECTS**

These examples show some of the effects that can be achieved by using paints with heavier pigments.

- Fast movements and strokes from side-to-side are useful for bright light on water.

- On wet paper, paint with heavier pigment, such as ultramarine or cadmium red, runs into the hollows of the paper.

- Dragging the side of the brush across paper gives a lighter effect.

- You can also make delightful colour runs. Here I used phthalo green, phthalo blue, ultramarine, magenta, cadmium red and cadmium yellow – the colours arranged according to the spectrum.

- The flat of the brush applied gently without dragging makes a still lighter effect and is useful for texture of rocks or masonry.

- Thick paint on dry paper runs into the hollows.

- A variety of marks can be made with the end and side of the brush.

- In overwashing thick paint is applied to dry paper and then washed over with clear water.

- You can also overwash with another colour – here, a wash of phthalo green was applied over a wash of ultramarine in the same way as the example above.

# Techniques for painting white

The best way to paint white is to use reserved or negative shapes – to paint the dark shapes first. It really isn't difficult, and it gets easier with practice. If you use the brush rather dry on a waterfall, the paper will do most of the work for you to create the white water.

There are other ways of painting light shapes using candle wax or wax crayons. These are great fun but very hard to control, and there is no way of correcting them if you get either the tone or the drawing wrong. With Rough paper and a dry brush you can get all the variety of texture you need.

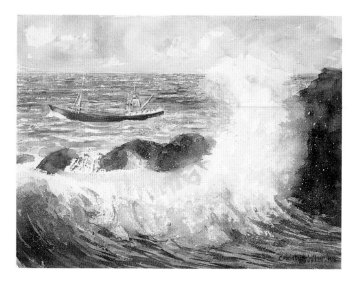

**THE SCALLOWAY TRAWLER** 28 x 38cm (11 x 15in)
This is a Shetland seascape. I used sprayed masking fluid for the spray, and the rest of the waves were done with reserved white. I composed this very carefully, using the curve of the wave to frame the trawler, which was lying quite low in the water and looked vulnerable in the heavy swell.

**WHITE PAINT ON A DARKER COLOUR**
I made these lines with thickly applied zinc white designers gouache. I could have made them even lighter by waiting for them to dry and applying more paint, but you can see that this doesn't have the brilliance of white paper.

**RESERVED WHITE AREAS**
Here, I painted the darks in, leaving the white paper to give the white lines of water flowing over a rock. This works well, but it becomes more difficult if the white lines are very small.

## Masking fluid

Paint the light shapes with the fluid. Next, paint the dark over the dried fluid. When this has dried, you rub it with your fingers or an eraser to reveal the clean white shapes beneath. Magic!

Or is it? The whole process takes longer than painting the dark shapes. Masking fluid is toxic and irritating to work with. It dries too fast and won't make a long, thin straight line because it clogs up the brush. It also ruins brushes. You must use it quickly and wash your brushes as soon as possible. If it does dry on a brush, remove it by dipping the brush in oil (olive or sesame) and working it gently with your fingers.

I only ever use it for bright bits of foliage and the odd touch of foam. However, if you don't mind messing your fingers, you can spatter it from a toothbrush, which is very good for fine spray. (If anyone knows about a slow-drying masking fluid, please tell me about it.)

**SPATTERED MASKING FLUID**
This effect was achieved by running a finger over a toothbrush dipped in masking fluid. The wash was laid over the dried spatters. When the wash was dry, the masking fluid was lifted or rubbed off.

## Blotting out

Use a rolled-up piece of tissue and dab into a wet wash to remove soft areas of colour. Useful for skies.

**BLOTTING OUT**
I used a rolled-up piece of tissue on a wet wash for this effect, suggesting clouds.

## Sponging out

This is similar to blotting out, but is done after the wash is dry. Oddly enough, sometimes the effect is softer. It is useful for second thoughts.

**SPONGING OUT**
To remove the pigment, I used a small wetted sponge on a dried wash.

## Scratching

Use a scalpel or any sharp, pointed tool. Be careful not to use any washes near the scratch, or they will run in and make a dark line. This is useful for very small touches and lines, such as distant masts and cats' whiskers.

**SCRATCHING OUT**
In this example I used a scalpel on a dried wash.

## Washing off

Put lots of clean water on the area you want to make paler, wait a minute or so, then sponge gently and lift off with a tissue. Soak in a bath for a large area.

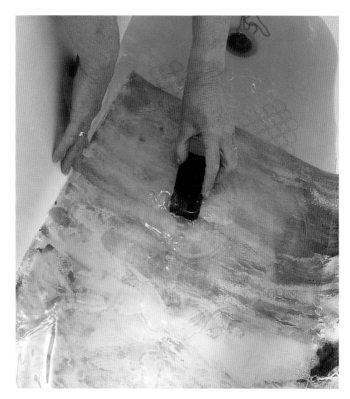

**SCRUBBING A PAINTING IN THE BATH**
I removed quantities of blue from the sea in this painting and have since then improved it a great deal. This only works with good-quality paper.

## Painting blacks

Rather than buying black paint, it is far more satisfactory to mix your own from the colours you have.

**BLACKS**
The black on the left was made with cadmium red and phthalo green, while the one on the right was made with ultramarine, cadmium red and cadmium yellow.

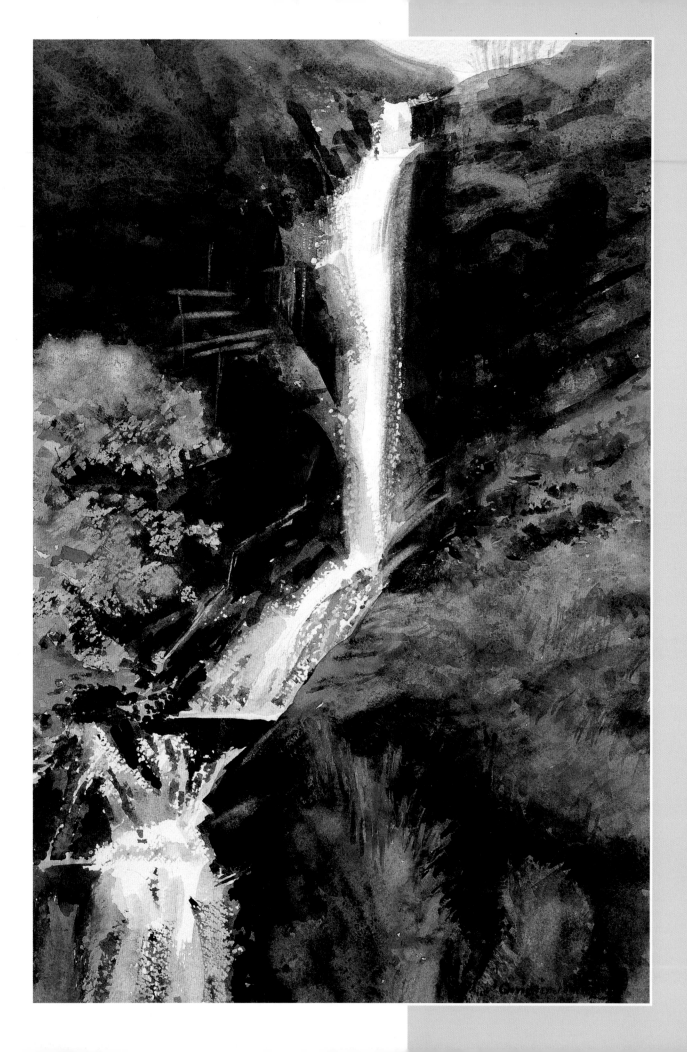

*'The darksome burn, horseback brown*

*His rollrock high road roaring down*

*In coop and in comb the fleece of his foam*

*Flutes and low to the lake falls home'*

*Gerard Manley Hopkins,* Inversnaid

# *chapter* 4
# Organization & improvisation

What happens when you start a painting? This chapter is about what goes on in your mind before any brush is put to paper, as well as what happens when you actually start to paint.

**CAMUS LUINIE** 56 x 38cm (22 x 15in)
I painted this rather fast, using the dark shapes to emphasize the simplicity of this single drop of water. The green shapes were done with colour dropped in and allowed to run together while the paper was wet. I applied the darks on the left-hand side before I put in the tree.

# Duality

We live in a world of duality. Polarities are not merely fun, they are fundamental to our reality. Light and dark, good and evil, storm and calm, silence and dynamism, chaos and orderliness – these are how we come to understand (if not exactly to explain) our surroundings. Contrasts are the stuff as well as the spice of life.

It is like this with watercolour – it is full of opposites. There is speed and slowness, light and dark. There is fast movement with lots of water, and there are slow, delicate passages with drier and thicker paint. And underlying all this there are the two forces that produce a successful painting – inspiration and organization.

These two opposite strands run through the history of art – they are at the basis of Romantic and Classical painting. This distinction goes beyond the artistic periods of that name. You can say, for example, that Van Gogh is a Romantic whereas Cézanne is a Classicist. But it isn't good to get carried away with these distinctions, because both streams are necessary and all good painting contains elements of both.

The Romantic element is to do with inspiration, passion, speed and intuition, the Classical, with order-

**HULK, BRESSAY, SHETLAND** 56 x 76cm (22 x 30in)
One of the many once-beautiful wooden fishing boats that lie rotting on coasts in the UK. I used reserved white for the whites on the hull, giving the texture with the flat of the brush. I did the sky with lots of wet paint and took a lot of trouble with the tonal variations on the distant hills because this is such a feature of the Shetland landscape.

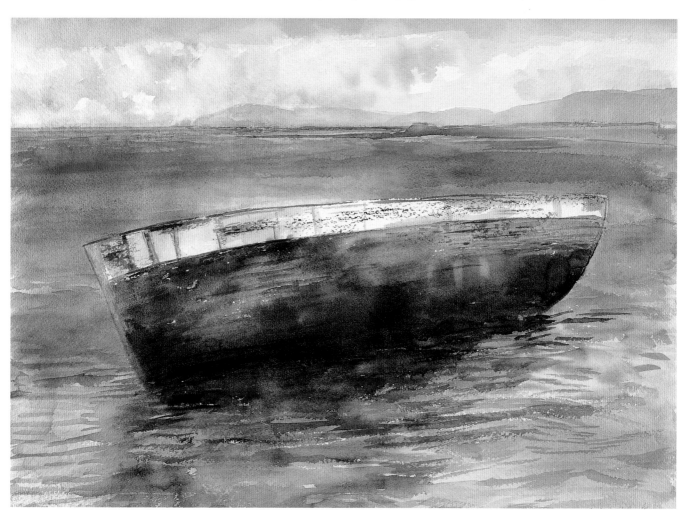

liness, organization, composition and intellectual deliberation. The Romantic painter works 'like one possessed', the Classicist with calm control. But even artists who work with frenzied speed have in the background a history of careful study, drawing and even failed attempts, before they can let go.

## Letting go

I know this from my own experience of painting High Force. This waterfall, in upper Teesdale in northern England, has obsessed me for many years. Over a period of two years I did eleven full-size paintings and one four times the size, as well as innumerable small sketches, colour studies and drawings. But it eluded me until one day when, feeling depressed about the number of rejections I had recently received, I decided that I would paint something 'just for me' and let go. I had no idea what I was going to paint. All I knew was that as I was feeling dark, it would have lots of black, or rather dark, colours, for I never use black pigment. I wetted the paper and started pouring in saucersful of dark colour, reds and blues and greens. In a mood of angry elation, I began to enjoy playing about, watching what the paint did for itself and seeing what I could contribute to it.

To my surprise, it began to form by itself into turbulent water and the dark rocks behind it. I had at last broken the barrier. It was my first satisfactory painting of High Force. Although this painting was done at great speed without any seeming forethought or organization, it was actually the result of all the preliminary studies. I could never have painted it for the first time like that (see page 94).

## Composition

You need to look at the whole composition and the ways in which the dark and light areas link up and relate to each other. At this point you are not looking at narrow tonal differentiation, but rather at the main areas of light and dark. In practice this usually means where the rocks are going and where the white water is placed.

Composition is an important abstract value. To begin with, it has to be organized carefully. After a time, this

**FRAGMENT OF A TORN-UP PAINTING OF HIGH FORCE**
This was one of my early versions of this subject. The treatment of the water in the fall, which I did with the flat of the brush and overlaid washes, is fair, but the rocks just don't begin to have any character at all.

seemingly cerebral process of deciding how to place the shapes in relation to each other, becomes more impulsive and intuitive.

The first thing to do when thinking about composition is to look at your material in a different sort of way. Mostly this is a matter of looking with the eyes half-closed and judging where the dark and light areas are – looking at them as shapes in themselves, rather than rocks or trees or falling water, how they fit together and whether they can be made, without too much distortion, to connect in a way that is more pleasing and more truthful to the reality of the painting.

Cotman and Cézanne are two artists who were superb at composition. It is a very good idea to make black-and-white studies (pencil or wash drawings) of some of their

landscapes, as well as to make tonal studies of your material. There are many mathematical rules about harmony in composition, and many books have been written about the geometry used by artists in the Renaissance, as well as by Cézanne. But it isn't necessary to study them. It is unlikely that Cézanne was conscious of the mathematical formulae that he was using because he painted so fast. On the highest level of composition, there just isn't time to compose by following rules.

But there are some rather obvious basic rules, like avoiding mirror symmetry, for example, and not using lines through the middle of the painting – if you were to draw together all the lines to show how it is composed, it should look more like a vortex than a Union Jack. A skyline bisecting a picture, or a big rock right in the middle makes a boring composition – if you have something large and eye-catching in the centre of the picture, you need to make sure that the spaces either side of it are unequal.

You need to think about the way the shapes relate to each other, and encourage them to do so in a way that leads the eye into and around the painting. The eye is attracted by curves and straight lines, and if you can gently emphasize these things in your painting, you will have a satisfactory composition. In addition, repeated shapes in different sizes make for good composition. It is a little like a theme and variations in music.

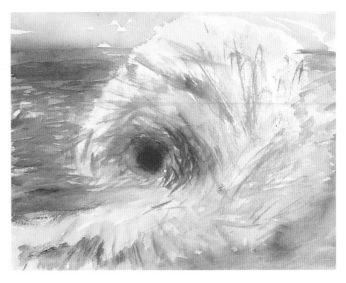

**SKETCH OF BREAKING WAVE**
This was a wave I saw in Dubrovnik and painted from memory. It fascinated me because it formed a spiral, so I brought that out in my painting, done with a flat brush. The vortex is the best shape to draw the eye into the middle and push it out to the edge in a satisfactory way.

There is another simple rule of composition which tends to separate beginners from experienced painters. This is to do with overlapping objects. If, for example, you are painting a house near a tree, you have to make sure that the tree is clearly either some distance away from the house, or partly in front or behind. Otherwise it looks weak. If you translate this into a water painting, you have to make very clear that the rocks are either in front of or behind the water – even to the point of exaggerating your material.

**BLACK-AND-WHITE STUDY AFTER COTMAN**
Making a monochrome study is a good way to understand the importance of organizing tones.

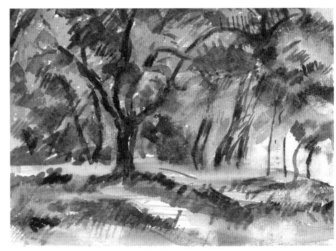

**BLACK-AND-WHITE STUDY AFTER CÉZANNE**
This study helps to show the importance of dynamism and energy in leading the eye around a painting.

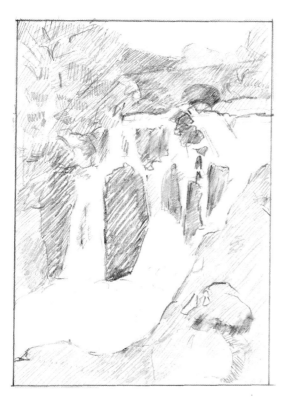

### ORGANIZING WHITE AREAS

In this drawing of the light areas of Eas Fors I have not put the tone in on the bank in the foreground – instead I have concentrated on the general organization of the white shapes of the water.

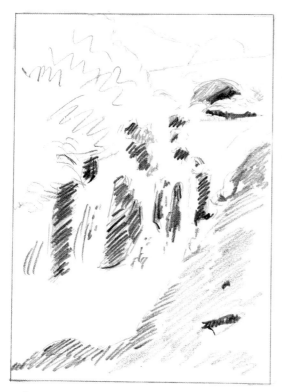

### LIGHT AND DARK

This sketch of Eas Fors shows the points at which there is the greatest contrast between light and dark. This gives the dynamism, or energy, of a composition.

### AVOIDING CONTIGUOUS SHAPES

When you look at a scene, you are bound to find at least a few shapes that overlap, and these are vital to bring a sense of space and authenticity to a painting.

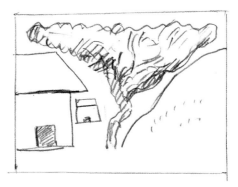

This childlike drawing (above) looks awkward and has no sense of distance or space. When the tree is put in front of the house and the hill (below), it all looks more real.

If rocks beside a waterfall are separate (above), they look contrived. Placed in front of each other (below), they look more realistic.

# Composing the falls

The vast scale and grandeur of some waterfalls makes them difficult to compose. High Force is one example (see page 94). There is a vast rock in the middle, which wants to dominate the composition, but if you make it too large you do not get in the waterfall or the magnificent cliffs on the left, which are the most important part of the river. Niagara is also difficult to compose because it is so wide.

I intend to paint the American Falls. Every one who visits Niagara is overwhelmed by the wonder of the Canadian Falls, and I was no exception. I was bowled over by this huge curtain of water surging over a cliff in unbroken fall. The American Falls were pathetic by contrast, because of the collapsed cliff that breaks the force of the original falls.

But this conclusion was the result of being blinded by the vastness of the Canadian Falls. By normal standards, the American Falls are magnificent. For my purposes the American ones are actually more interesting because there is the contrast of huge amounts of boiling water and large, dark and savage rocks. If I were going to paint the Canadian Falls, I really would need a larger bit of paper – maybe the size of a wall – because all their appeal lies in their colossal form.

I have now done three colour sketches of the American Falls – the first one quite small, the others larger. A large waterfall has a tremendous range of shapes. Here we have lots of diagonal and horizontal movement as the water feathers over the cliff.

In the first sketch, I was looking mainly at the dark shapes – the pattern of the rocks and how they relate to the darks at the top and bottom of the painting. I was going to make it in black, but just couldn't resist colour – there isn't very much of it, anyway, in a mostly white waterfall falling over black rocks. I was also interested in the dynamism of the horizontal and curving movements of the falls.

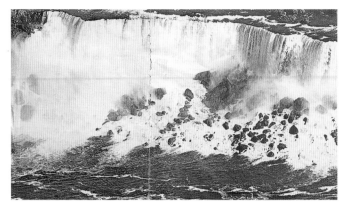

**THE VIEW** This photograph of Niagara surfaced when I moved house last year. I cut it out of a paper in 1972.

In the second and third sketches I was looking more at the detail of some of the passages of water that most appealed to me – the feathering movements and the tones of the mists that spread over the rocks. The second sketch is a detail of the rock cluster in the middle of the falls. This forms part of a diagonal movement running across the whole composition, which forms a pivot for the vertical movement of the falls to the left and right of it and the horizontal lines of the top of the falls and the base. The third sketch is a detail of the water on the left-hand side as it falls in shadow over the cliff. This contrasts with the water on the right which is in bright sunlight.

Having made these sketches, I realized something about the problem of conveying scale. It is not as hard as it might seem, because large masses of water behave in a different way from small amounts. Two things happen – the water bunches up into great loops and scallops, and there is also a huge amount of spray. With the Canadian Falls, the spray rises up higher than the cliff.

Apart from these two differences, there is a similarity in the way the water behaves. There is the same feathering movement, but the scale is smaller in a painting of a big waterfall, because the size has to be reduced further. This phenomenon is something that the eye understands – it doesn't need to be formulated.

The conclusion is that scale is not a such difficult issue. If you observe the water accurately, the scale should look about right – you don't need to add things like people or boats.

44

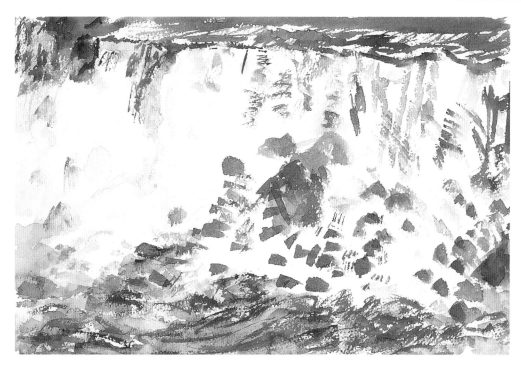

**NIAGARA SKETCH 1**
This is a preliminary small sketch to place the waterfall. I was looking at the shapes of the rocks and how they related to the light shapes. I was not too bothered by the details of the water.

**NIAGARA SKETCH 2**
I was looking at the rocks in the centre of the picture. They were blurred by the spray, so I used lots of water.

**NIAGARA SKETCH 3**
This time I was looking at the detail of the falling water. I put the darks in with the flat of the brush and overwashed to give the flow of the water, the colour in the washes coming from the darks.

45

# Organizing techniques

After organizing the composition, the next thing is to decide what techniques you are going to be using in what areas. For a painting of Niagara, for example, I would make the following decisions about technique. The sketches of Niagara were done with a square-ended brush, which will produce the inverted triangular shapes of a rock with water rushing past in one go. It is also very good used with almost dry paint to get the delicate feathering effects. For this, I wet the brush in the colour and then blot most of it out with a tissue, before using it very delicately on its narrow side.

Since Niagara is all white and light tones, there isn't much deciding to do about reserving white areas. There won't be any heavy washes in this painting, and although some of the colours will be allowed to run, it won't be a matter of dropping colour onto wetted paper. I will probably use washes to state the final tones over the drybrush work, and a sponge to make things smoother. The top and base of the waterfall are a deeper colour and may require superimposed washes. Probably the only part where I will use a round, pointed brush will be for the deep line along the top of the fall, just where the water begins to break over the cliff. Finally, I will make some detailed studies of the foreground rocks before starting the large painting.

## Enter inspiration

So much for organization. But it isn't really just a matter of going from one facet to the other, because inspiration and organization go hand in hand throughout the painting. Nor is it so much a matter of taking the correct angle and letting go, as repeatedly aiming and letting go. The really interesting thing is that in time the two processes begin to merge, and in really peak performance they are simultaneous because the intuition does all the calculation on a subtle level. This is, of course, when you are on the level of genius. A composer like Bach, for example, just went to the organ and improvised, a lot of the time. He didn't work out for himself the enormous mathematical patterns that musicologists delight in revealing in his work.

## Confidence and mess

So how do you start a painting? When you are painting water, if you have not done much painting before, it is a good idea to postpone the moment when you begin to paint a waterscape.

The reason for this is that watercolour is a more immediate medium than oils and acrylics. You cannot pile the paint on thickly. Although it is possible to do more correction than people who have not had the experience of working on heavy watercolour paper suppose, there can come a time of disillusion – a feeling of having missed it.

The main enemy of painting in watercolour is the internal one. This is why I have emphasized that you must build up a happy relationship with your subject before you start. But even that is not enough, because the feeling comes that you are not doing justice to your subject. What you also have to do is to build up a happy relationship with yourself. This is because it is the internal voice, the result of schooling or parental restraint, which says that you cannot do it – there is no point in even attempting it, you are just going to make a horrible mess, no matter how much you have spent on tools and materials.

So an important part of the organization of a painting is the process of dealing with self-doubt. You can do this in various ways. There are simple things to make you feel good when you start, and there are also

**A STREAM IN A RAINFOREST, BHUTAN** 38 x 28cm (15 x 11in)
What I like about the tropical foliage in these rainforests is the way in which the branches and leaves go in unexpected directions. I have used this to emphasize the movement and energy of the stream. I painted in the negative shapes for the foliage in the foreground.

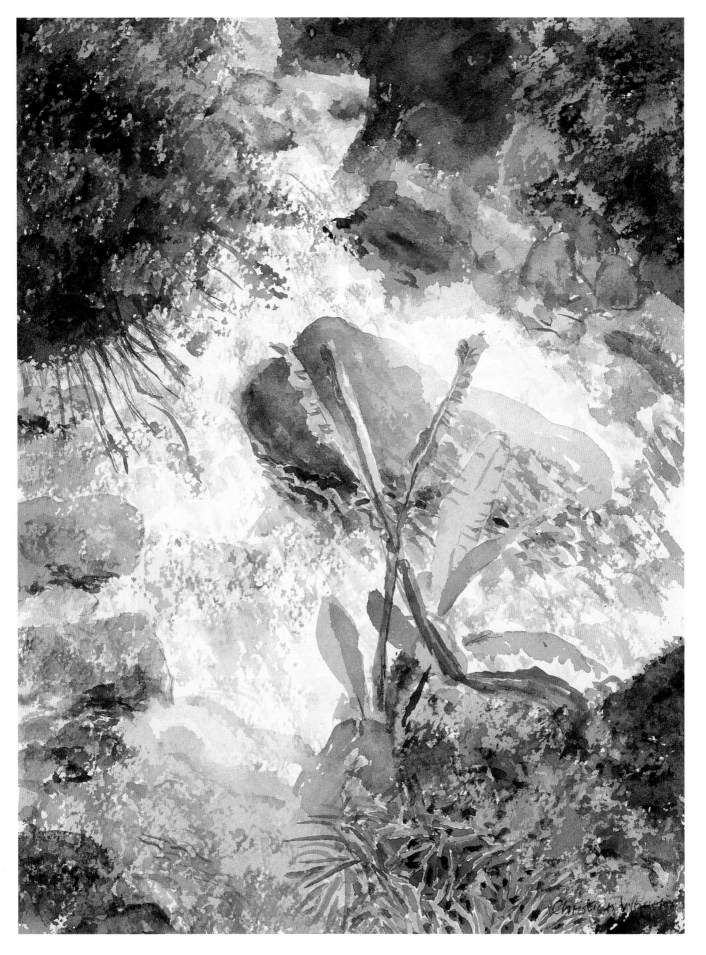

techniques for building up confidence with brush-work. I start with the latter, because these are what you will be doing before you come to start the painting. I have always felt that the real implications of 'abstract', or rather 'non-figurative', art are for art education rather than the general public. For years I have taught this way. By freeing the student from the concept of having to paint something that is tied to a visual image, the teacher can build up a sense of liberation and confidence, as well as the ability to experiment and improvise.

One of my students once turned to me incredulously and asked, 'Do you mean I can make a mess?'

'Not only can – but should.'

We are all much too afraid of making messes, and I think this is the real purpose of many contemporary art movements – the lessons we can learn from making and looking at messes.

So I am going to suggest that you start making some paintings of water, without any relevance to any particular piece of water that you want to paint. You should make some paintings of wild waterfalls, as well as deep pools and rocks with lots of reflections. Just paint quite freely from inside you, without worrying too much about an image. It is a very pleasant experience and completely frees you from the internal voice of inhibition. It also gives you some much-needed practice in the techniques already described.

You should do lots of these paintings. Use lots of paint and lots of water, and enjoy the possibilities of the square-ended brush. It has three faces you can work with – the tip, the side and the flat – so use all of them.

Messing about with watercolour – like 'messing about in boats' – is the way to conquer pre-painting nerves. It is also a very important way to find out just

**IMPROVISED PIECES**

Putting paint to paper without a defined subject can be very rewarding, particularly when it comes to the way you start a painting, and to relax you about the work. I was thinking about the translucency of water when I painted the piece above. The one below, with lots of black shapes, was great fun to do.

what happens and how to use the techniques in a number of different combinations.

You should make notes on the back in pencil about how any effect that particularly pleases you was achieved technically.

## Now what?

Having done this – having chosen your subject, assembled your preliminary material, drawings, sketches,

**A PIECE OF IMPROVISATION** 28 x 38cm (11 x 15in)
In this study I was experimenting with heavy pigment and also enjoying the shapes made with a square-ended brush. I used colours that I hardly ever use, but which do have heavy pigments – manganese blue and raw sienna.

photographs, and all your painting tools and materials – you should be ready for the attack. What next?

There is, I believe, much too much emphasis in art education on the process of painting and far too little on the person doing it. It seems so obvious it hardly bears to be said, but the painting does reflect the condition of the artist at the time of doing it. If you are tired, depressed or have a hangover, then you may be attempting to paint the most sparkling water in the world, but what your painting will express is your stress. (At this point, I can hear someone saying, 'But what about art therapy, isn't that any good?' Of course it is! Of course art can be used for remedial purposes, but you don't always want to put the result up on your wall.)

## Working at your best

Much of what I have said about inspiration and organization can be compared to what athletes call 'the zone'. This is an experience of working at peak performance, with the body functioning with maximum efficiency on the minimum amount of oxygen. In painting, this is to do with having let go of all the internal voices of self-criticism as well as that part of the brain which deals with mortgages, dental appointments and insurance. So when you are about to start a painting you need to have this in mind. You need to organize for inspiration.

Working in 'the zone' may not come all at once, but it will come if you give priority to these things. Take care of yourself – I have already dealt with the physical side of this. The other side is the spiritual one.

Now you may be the sort of person who finds the very word 'spiritual' utterly meaningless. It doesn't matter, because the fact that you are reading this book means that you have a part of you which is not locked into a materialist mode. If you love art, music or poetry, you have some awareness of unworldly values. Putting your attention on these is the most important part of starting a painting, now that you have reached that very special moment when you first put brush to paper.

So there are two things you have to do. One is to take care of the practicalities. Get rid of all the things that have been nagging you: sort out your in-tray, make the boring phone calls, pay off debts. All these minor matters are a drain on your energy and creativity. It is like clearing out clutter and rubbish (which is also something good to do). Then you can have the phone off the hook and give yourself some peace.

The other thing is to take some time to settle into the 'other-worldly' side. There are all sorts of things you can do – music is helpful, so is poetry; yoga and meditation are excellent, and some artists light a votive candle or burn incense. Anything that you can do which brings a sense of gratitude for the privilege of being able to put paint on paper and express something utterly beautiful, will remove your awareness from internal negativity. It will help you to forget the past and the future and just live in the moment – this is one of the main features of 'the zone'.

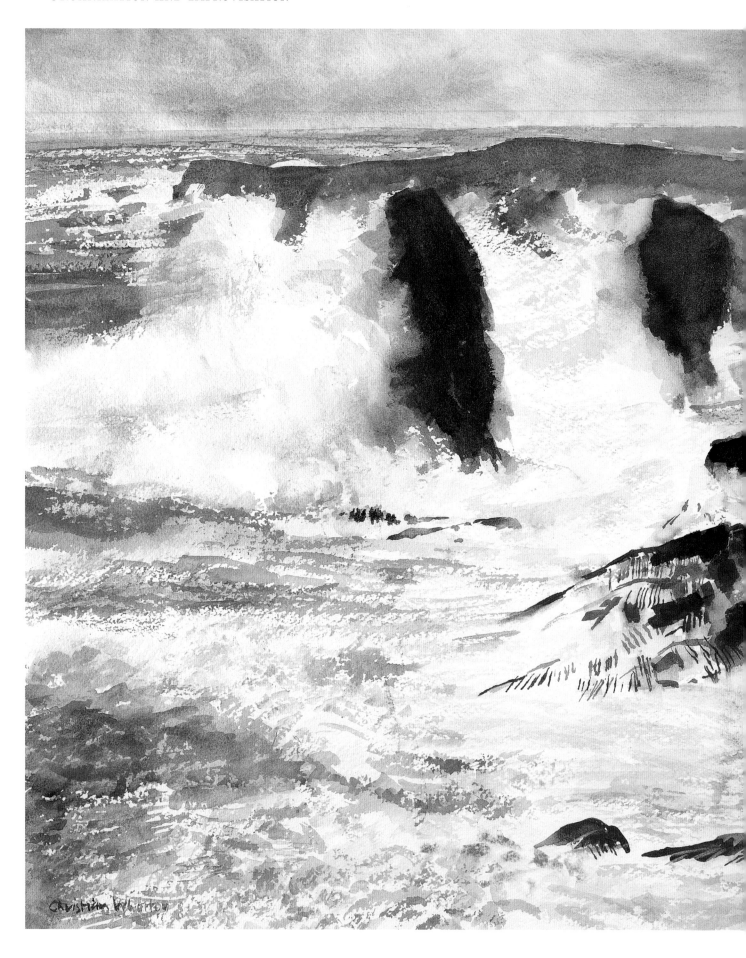

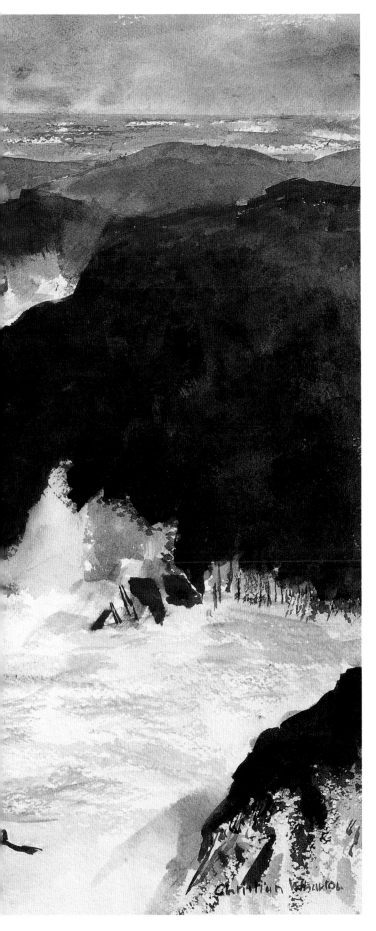

## How not to do it, and how to

We can learn from those Victorian governesses who instructed their protégées in the art of watercolour, how not to do it. It is very practical and sensible to start a painting in the top left-hand corner (if you are right-handed) and work your way systematically across and down from side-to-side. You won't smudge the work with your hand or get paint on your pretty, ruffled cuffs. But this is working in left-brain mode, that part which handles reading, writing and arithmetic. We know now from Betty Edwards' excellent book, *Drawing on the Right Side of the Brain*, that painting is different.

What you have to do is to take in the whole sheet of paper in front of you and visualize the finished picture. It doesn't matter if you find that you cannot do this – it gets easier with practice, and even if you can't, this exercise helps you to think about the whole and not get distracted by the details. It is a bit like taking an overview or distancing yourself. And when you do this, when you look at something further away, you see the salient points, the things which really hold it together. These are the things you have to paint first – things like the points of greatest dynamism, where the contrasts of light and dark are greatest (see left-hand drawings on page 43). Any lines – curving, horizontal, vertical or diagonal – that carry the eye around the picture should be established at the earliest point.

Your first brushmarks should lay down the anatomy of the movement in the painting. You do not need to think too much about colour at this point – any neutral, greyish brown will do. You should move the brush freely round, just enjoying the shapes. And if you do this, this feeling will permeate the whole finished painting and the onlooker will also feel some pleasure.

**STORM, ESHANESS** 56 x 76cm (22 x 30in)
(From a photograph courtesy of Colin Baxter)
Eshaness in the north of Shetland is pounded by magnificent waves after any northerly or westerly gale. I used wet paper and dropped in pure colour – blues, reds and magenta – to make the cliffs. The rest was done with thinner washes mostly applied with a square-ended brush.

## Moving on

These first steps were easy, but now some colour and accuracy has to come, and the whole thing could easily be spoiled. This is where you have to remember that painting is not only a journey of self-discovery, it is mostly self-taught. Nothing that happens is ever a disaster. I have seen students tear up their work in despair – this makes me so sad, since the fact that something doesn't measure up to some internal standard doesn't mean that it wasn't worth doing. We have to do it in order to get to the next stage – like avoiding a block, we may seem to be going backwards, but we are going backwards in order to advance.

So having made those first marks and established the basic composition, you organize the next stages and choose the colours and the techniques (deciding where you will use wet or dry paper, for example), if you have not already done so.

Mixing colours is great fun – take your time over it and enjoy experimenting on bits of scrap paper. If you have large washes to do, mix more than enough, so that you do not have to break off in the middle of a wash to make some more.

Be bold and confident, even if you are neither of these things. Just do it. No-one is looking over your shoulder, gasping with shock. If you accept that everything that happens is a step in the right direction, even if it looks awful, the painting is a success and you have achieved something.

Keep the brushmarks loose and relaxed. Painting should feel effortless in the early stages. The brush should feel as though it was dancing over the paper in graceful swirling movements.

## The next stages

At this point in the painting, you should be establishing the areas of large washes. When these are done, you start going over the whole thing and putting in more detail. This is where it gets a little more – well – challenging. It is so easy to get carried away and start putting in detail when a wash is not quite dry. My method is to have several paintings on the go at once, so that when one painting is all wet, I can work on another until it is dry. This also means that I can get a little break from the first one.

Having a break is important – almost as important as starting. It is so easy to get carried away by a painting and then get too tired. When this happens you stop being able to see it, and before you know it the whole thing sags and becomes tired itself, and you try to rescue it by putting in too much detail. When you have been painting for an hour, give yourself a rest. Allowing yourself a break will help you to get back into the feeling that you had when you started it.

When it comes to detail, this is a part where organization is important. It is hard to generalize because every painting varies, but as a simple rule you should put in only those details which give the essential

**BREAKING WAVE, BARRA** 38 x 28cm (15 x 11in)
This was done mostly with the flat of the brush, although the distant hills were painted with washes from a round brush. Careful tonal observation was necessary for the patterns of light and shadow on the hills.

character of the scene you are painting. It is very easy when you are tired and out of 'the zone', to become obsessed with detail, so giving yourself a rest is the best thing you can do.

## Intuition

When you are in 'the zone', the two processes of intellect and intuition, which seem so separate on one level, on another much deeper one are practically the same thing. I have already mentioned Bach and Cézanne achieving amazing intellectual constructions without much apparent effort at organization. On the level of genius, the intuition is able to compute with unbelievable speed and effectiveness. Perhaps Mozart is the supreme example of this.

For my own part, without any pretensions to genius,

**PUFFIN AT MINGULAY, NEAR BARRA** 28 x 38cm (11 x 15in)
It was not possible to paint this beach without putting in a puffin, because these fearless birds are all around you. I painted the rocks and grass with a dry brush, while the buttercups and thrift were done with little jabs of paint in the white spots left by the rapidly brushed-on green. I then filled in the backgrounds to the flowers. The waves washing onto the beach were done with delicate, thin washes.

I find that the two sides have become closer in recent years. When it comes to water, my brush seems to know what to do without being consciously directed. It means that sometimes it is hard to explain why I am doing certain things – they just happen, and I only really understand a long time afterwards. On the other hand, it is wonderfully blissful, and I would love everyone to have the joy of this experience.

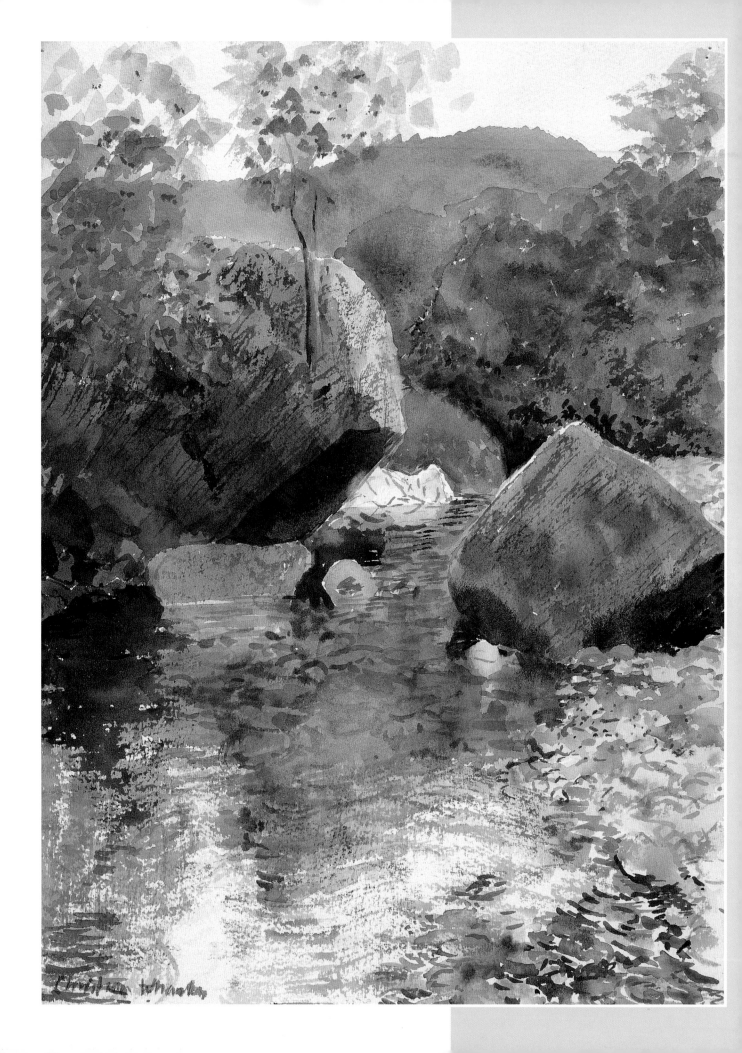

*'The sound of water escaping from mill-*
*dams , etc., willows, old rotten planks,*
*slimy posts, and brickwork… those scenes*
*made me a painter and I am grateful.'*

*John Constable, Letter to John Fisher, 23 October 1821*

# chapter 5
# Five elements of a waterscape

After looking at waterscapes from the
point of view of the whole painting, we
now consider the various parts in greater
detail – the whole is more important than
the sum of the parts!

**ROWAN TREE BY A HIGHLAND STREAM** 38 x 28cm (15 x 11in)
It took a lot of careful tonal adjustment to get the rocks under the
stream, as well as the ripples and reflections on it. I used thin washes
for the foliage, allowing the paint to blend in, and added the tiny
spots of the red rowan berries as a finishing touch.

# Introducing the elements

These five parts are: skies, distant landscape, trees (including bankside foliage detail), rocks and water. You know enough by now not to attempt a painting in this sort of system – starting at the top and working down. But it does make sense to put the sky in at an early stage. I generally leave the water until the end, because this is what I enjoy most – it is the icing on the cake. But this also makes sense if it is white water that you are painting, because you have to reserve the white areas.

Of course, water (and perhaps rocks) are the only really essential elements. A waterscape does not need to have all the others – mine frequently don't – but it will always have some of them. Niagara may not have any sky, for example, because it is impossible to compose a painting of the falls that gives an idea of their scale without showing the nightmare of the whole Niagara fairground.

Although four of these elements are not water, they are just as important. Something might be a background feature that doesn't have the same emphasis as the foreground, but even as background, it has to be considered carefully and related to the whole painting. I have already suggested that you do some loosening-up paintings of water, and hope that you are pleased with the results. But when we consider a waterscape, we have to look at the environment of the water. It has to be the whole thing.

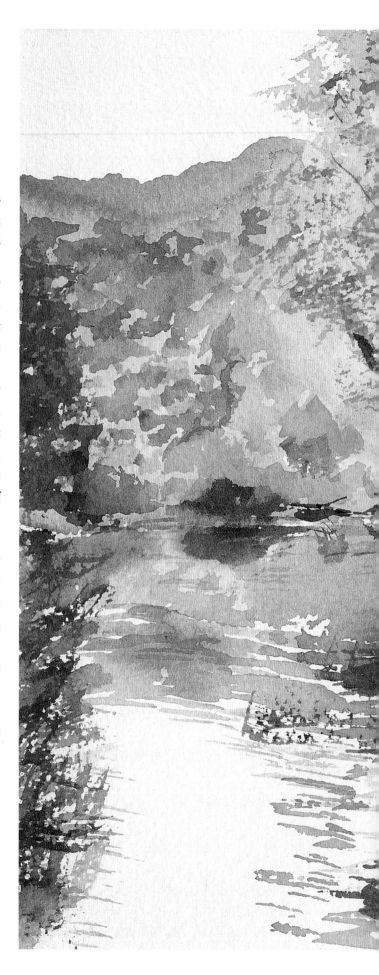

**LAKE WITH A WATER PRAYER WHEEL, GASA DZONG**
28 x 38cm (11 x 15in)
I was attracted to this scene in Bhutan because without the water wheel, it was just like England – it was a grey day and everything looked moderate. I put the ripples in and then added more colour to give the reflections. The trees were done with a mixture of dry-brush and washed-in colour.

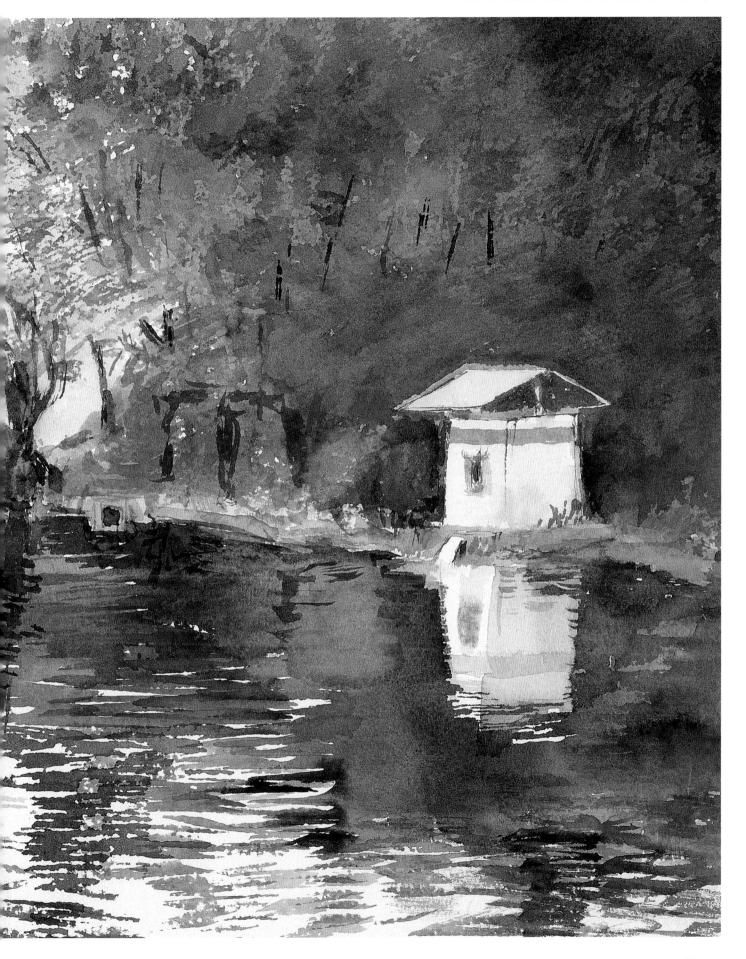

# Skies

There are only two kinds of sky – clear and cloudy. Clear skies might seem the safest option for a beginner, but in order to paint a clear sky you have to be able to do a really smooth gradated wash.

## Gradated washes

There are two ways of doing a gradated wash. The first, or traditional, way is to make a wash of diluted blue – phthalo blue with a little ultramarine is best. Then apply it in long, smooth brushstrokes across the paper from the top downwards. Work on a slightly angled surface so that any drips fall towards you, catching them with each successive brushstroke. As you move downwards add more water, either to the wash or straight onto the paper with the brush – it depends on the dilution of the wash. Finish by running a squeezed-out brush along the bottom to catch the final drip. If you are using Rough, sized paper you mustn't go too fast, because if you do the wash will not take properly onto the paper and you will get a mass of sparkles where the white paper has resisted the paint.

You can use this technique if you are planning to paint a distant landscape over the dried-out sky wash, where this works very well. A refinement of this process is to do two gradated washes, one on top of the other when the first one has dried, turning the painting upside down for the second so that the concentrated colour is at the base. This would be useful for a sunset.

The second technique is useful if you are adding in the sky after painting the distant landscape. Wet the whole surface with clear water and run in the blue from the top, gently drying it out as it moves downwards. This does not give as controlled a gradation as the other technique, but it is fine if you just have a small area of sky to do, or if you want to add clouds or a ridge of mist.

**PAGES FROM MY SUNSET SKETCHBOOK**
I had to work fast as the scene was changing, so I used wet washes for speed.

**CLOUD STUDY**
For this study I used both blotting and sponging techniques with some reserved white paper for the shape of the clouds.

# Clouds

Clear skies are all very well – but clouds are what we mostly live with. They are simpler to paint than gradated washes, but they can so easily go wrong. You think a cloud is just like a mass of cotton wool or a lump of grey, but when you paint it, your eye instantly recognizes that this is wrong. It just isn't like a cloud.

Clouds have to be painted from direct observation. There is no excuse for not painting skies from life – most of us have windows. It is good to practise and make studies of clouds, as there is much more to them than there seems at first. If you really don't have a view of the sky, probably the best thing you can do (and maybe this is a good idea anyway) is to get hold of a book of Constable's cloud sketches and make copies of some of them. His sketches were so accurate that they were used by scientists studying weather patterns.

It is very enjoyable to sit watching clouds and try to capture them in paint as they move across the sky. Watercolour is a better medium than anything else for fast-moving, heavy, wet clouds. You need to work fast, with lots of water and washes of grey, brown and blue. Clouds reflect the light all round them, and this can bounce off the ground, as well as off other clouds. You have to learn to distinguish between blue-biased clouds and brown-biased ones. Depending on the time of day, and the season, the darker areas will move to be above rather than below the mass of the cloud.

You will find that you can get wonderfully simple effects by dropping in paint and blotting out areas. I work with a piece of tissue in my hand. But this cannot be done to formulas – it has to be based on observation. Again, it is worth keeping a notebook, just for clouds.

After a while, you will find that you know enough about clouds to be able to fit them into the background of a waterscape. Then you will be able to shape them to enhance the composition and complement the forms on the ground.

**FLAT WASH**
Make a wet wash on Rough paper.

**BLOTTING**
Blot off the wet wash with a tissue to make a cloud.

**SPONGING**
Use a wet sponge on a dried wash to lift-off colour to make a cloud.

# Distant landscapes

As I've said before, the whole painting is important, not just the dominant feature. Distant hills are not just 'background', to be fudged in somehow – they are part of the character of the landscape. I am always very careful with the outlines of hills; they are the only things I draw in with pencil. For me, they are like the features on a face – they have to be right.

I am prepared to exaggerate the height of a hill if working from a photograph. This is because the camera makes the hill seem smaller than it does to the naked eye. The other point to make about distance and landscape is that you have to be careful when observing the tones. Tone in painting means the amount of light or dark in a

**TONAL STUDY OF HILLS BEHIND HILLS**
This was done with superimposed washes, taking each wash down to the base and allowing them to dry between applications. For the two farthest ridges, I used the same wash, but for the nearer ones I added small amounts of darker tone each time.

colour. Distance affects tone: a red mailbox next to you will not look the same tone as one half a mile away, and one a whole mile away will be a different tone again.

Space and distance lighten the tones, and also affect colours, making them bluer and cooler. If we take, for example, a hypothetical landscape, perhaps based on the Blue Ridge Mountains in North Carolina, where you can see as many as 12 separate ridges all at once, each would be a successively paler area of colour. This tonal exercise can be done in any colour; when you do it in two colours, with green in the foreground gradually becoming blue in the background, you get a very pleasing effect.

However, there is more to it than that, because in real life atmosphere and weather also affect tones and colour. There is usually some haze or mist in the distance, so the ridges tend to have deeper tones towards their summits. Then there are the effects of sun, cloud and shadow, which can turn the whole neat ridge scheme upside down. This is when it gets really interesting, when you have dark ridges, further away than light ones. Cotman loved painting this effect. It is even more entrancing when you get a dark sky over a light horizon, because once again this is the reversal of a norm.

What Cotman did was to simplify the areas of tone. For example, if he had a mountain or a slab of rock, he would treat it all as one flat plane, almost as if it were a cardboard cut-out. Within that plane he would make very delicate tonal adjustments, but nothing like the

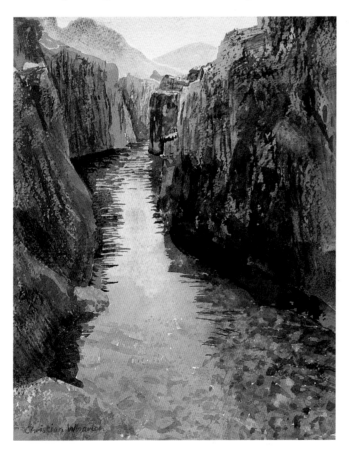

**BLACK MOSS POT FROM THE SHALLOW END** 38 x 28cm (15 x 11in)
I did the rocks with the side of a flat brush, and gradated the tones of the reflection of the sky, which got darker as it approached the shallows of the foreground. In the shadow under the rock at the right, the outlines of the rocks are much more clearly delineated.

scale of anything that was outside it. He called this technique 'pattern-making', and it produced some of his more beautiful paintings, like *Greta Bridge* (below).

The other thing about hills is their edges. In nature, you hardly ever find dark lines around planes. But watercolour tends to dry with hard edges, unless you are working on a slightly damp surface, and even then you can still get lines where you don't want them. So if you find that you are getting lines, or those disconcerting wiggly watermarks that ultramarine tends to produce, you can get rid of them by moistening them with the point of a wet brush and lifting off with a cotton bud.

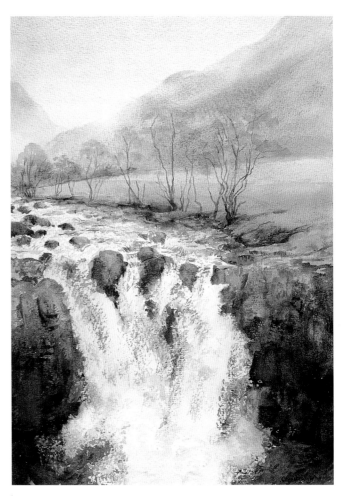

**GLEN NEVIS** 76 x 56cm (30 x 22in) (right)
In order to give a sense of distance, I used thin washes, sponging out for the mists. I also used thin washes for the trees, and dropped lots of red into the darks of the rocks by the water.

**GRETA BRIDGE** JOHN SELL COTMAN, 1805 (below)
Cotman organized his material into four main tonal areas, so that the dark shapes – the trees and hills in the background and the reflections in the water and the shapes under the bridge – interlock with the lighter areas – the building on the left, the bridge and the lightest part of the water. He made the rocks in the foreground dark to counterbalance the light in the water.

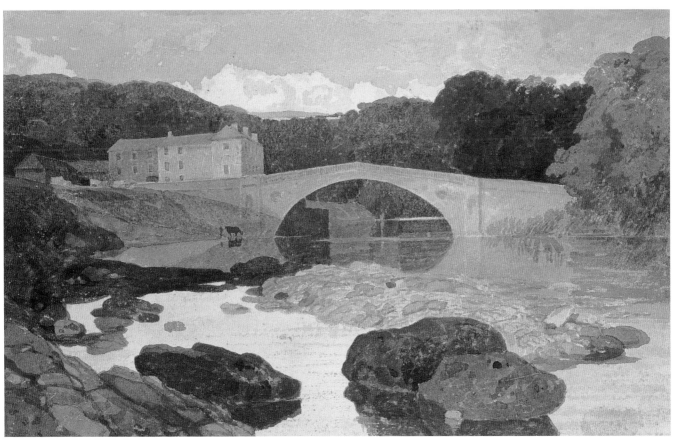

# Trees and foliage

Trees need to be carefully observed and drawn. If you have trees or bushes near your home, you should draw and paint them for practice. What makes an accurate depiction of a tree is accurate rendering of a certain percentage of the negative shapes, or rather the holes between the leaves. It doesn't need to be all of them – you do not need to draw every leaf – but you do want to give a feeling of the general form.

**THREE-TONE STUDY**
I put the darkest tones in first, then the medium ones, which I washed over the dark just to soften the edges. The highlights were left white.

## Exercise: tonal tree

It is a good exercise to make a tonal study of a tree. Mix up three different shades of brown or green – one light, one medium, one dark. (Brown is mixed from yellow, red and blue, or green and red.) Then, looking very carefully at the negative shapes and the darkest areas, such as the undersides of the leaves, paint them in first. Let the paint dry and then paint the medium areas, leaving out the lightest ones, of course. Finally paint the lightest areas, and if there are highlights, either leave them white or wash over with them with clear water, which will drag sufficient colour out of the finished washes to just tone down the lightest areas.

People ask me why I paint the very darkest tones in first, and then paint over them. I do this because I like the effect of taking a bit of the heavy dark wash into the next tonal stage – it gets rid of any hard edges and it also saves mixing so much colour, because of course there are more than three tones in most trees.

This is a rather boring process, but it will give you the practice you need. When you know a bit more about the way trees behave, then you can use more interesting techniques with dropped-in paint and lots of drybrush work. But there is no escape from the importance of accurate negative shapes.

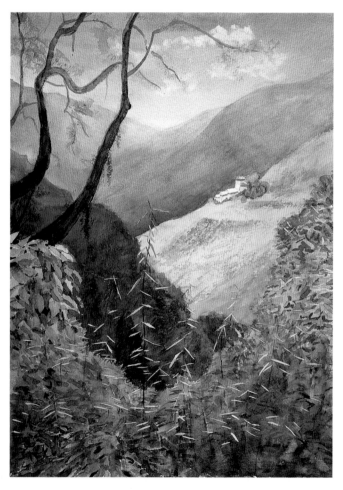

**GASA DZONG FROM THE FOREST** 76 x 56cm (30 x 22in)
The foliage was done with a mixture of carefully painted negative shapes – the leaves to the base of the trees on the left, wet colour allowed to run in the bottom right-hand corner, and masking fluid on the bright narrow bamboo leaves.

## Branches and twigs

You very rarely have a full-frontal tree in a waterscape; more often, you find branches over the falls and distant woods and bushes on the hills. Bare branches and winter trees are some of the most difficult things to paint well – you want to convey them accurately, but without painting in every twig. Drybrush is useful for this, and I also find the tip of my square-ended brush very good for making thin branches. Thin washes also suggest the bare branches of winter trees, and small amounts of paint dropped onto a wetted surface can make bushes on a skyline.

If I am painting a waterfall with many branches obscuring it, I leave out most of them. It is nice to be able to do all this landscaping without being accosted by environmentalists!

## Leaves and foliage

Foliage by itself, like the undergrowth in the rainforests of Bhutan (opposite below), poses problems. The detail of the actual plants was so fascinating, I wanted to convey their character. But I did not want to paint each one leaf by leaf. So I compromised and used a combination of techniques, masking out the very bright thin bamboo leaves, delineating a selection of the darkest shapes and carefully outlining some of the very bright leaves. I also used lots of washes and dropped in colour to suggest the dark areas. I used this technique in *White Water in the Mo Chu* (below right), but here I included drybrush work.

There is not quite the same variety of bankside foliage in the Northern hemisphere as in Bhutan, but whatever there is, it has to be painted accurately because it gives the character of the place.

**WHITE WATER IN THE MO CHU, BHUTAN** 56 x 76cm (22 x 30in)
This river drops great distances as it descends from the high Himalayas, so the action of the water is wonderfully powerful. It is also glacial, so it is rather milky in colour. I used the diagonal movement of the rocks to emphasize the curves of the water and the warm tones of the trees as the light fell through them, to contrast with the cold blues of the water. I used masking fluid for the foliage in the foreground.

**LOOSE TREE FOLIAGE**
Here I used the side of a brush to make a tree shape.

**THICK TREE FOLIAGE**
In this study I used thin washes to build up the shape of the foliage.

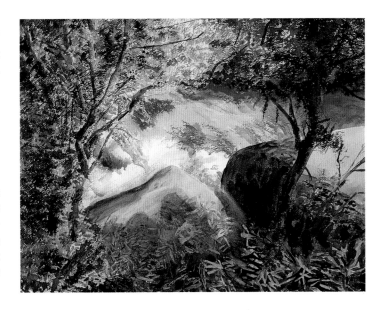

# Editing your paintings

When you have busy foreground detail, the problem is not so much what you put in, but what you leave out. If you put in too much detail, the picture becomes overworked and dull – your viewers are being given more information than they need. On the other hand, too little information makes a scene look generalized and uninteresting. When I saw the scene of the River Nevis (opposite), I was enchanted by the buttercups in the foreground. But I didn't paint every single one of them.

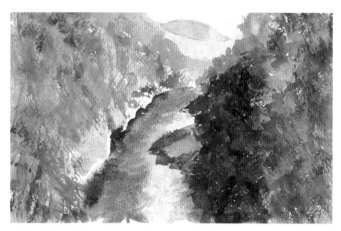

**QUICK STUDY FROM A POSTCARD**
I used a dry brush for most of this study and then washed over to get the main areas of dark, and finally added the hill in the back ground. It took ten minutes.

The ability to edit comes with time. But if you want to learn how to do it quickly, the thing to do is to practise trying to get the essentials of a scene done in a very short period of time – like a gesture drawing in a life-drawing class. This is because the eye has a natural ability to select the vital information, and all you have to do is to learn to allow it to do so. I make my students do quick studies from postcards that I let them look at for a few minutes and then turn over. There are never any unnecessary details in these works.

You can also make a study of something that has a lot of texture in it. I used to have a long-haired sheepskin rug. Its shaggy hair lay in all directions, and it resembled a piece of turbulent water. As the subject of a drawing

exercise it was invaluable, because it taught the student not to be daunted by the inability to draw in every single strand, but to go for the salient, the important shapes that gave the general feeling of the rug.

I don't know what the exact percentage is, but if you have a sufficient percentage of accurately delineated outlines as well as accurately perceived tonal gradations, you can convey the subject successfully.

Why not just go for all the details, even if it takes a long, long time? The answer is that the details are all parts of a whole, and if you pay too much attention to them then the parts become more important that the whole and the picture looks tedious – or sometimes, if it is very well done, even rather sinister. This is because the attention is being drawn to superficial areas rather than the subtle ones which, I believe, is the real purpose of art.

**RUG DRAWING**
Made in charcoal pencil, this quick sketch emphasizes the importance of getting the directions and movement of the strands right, rather than trying to draw in every single one.

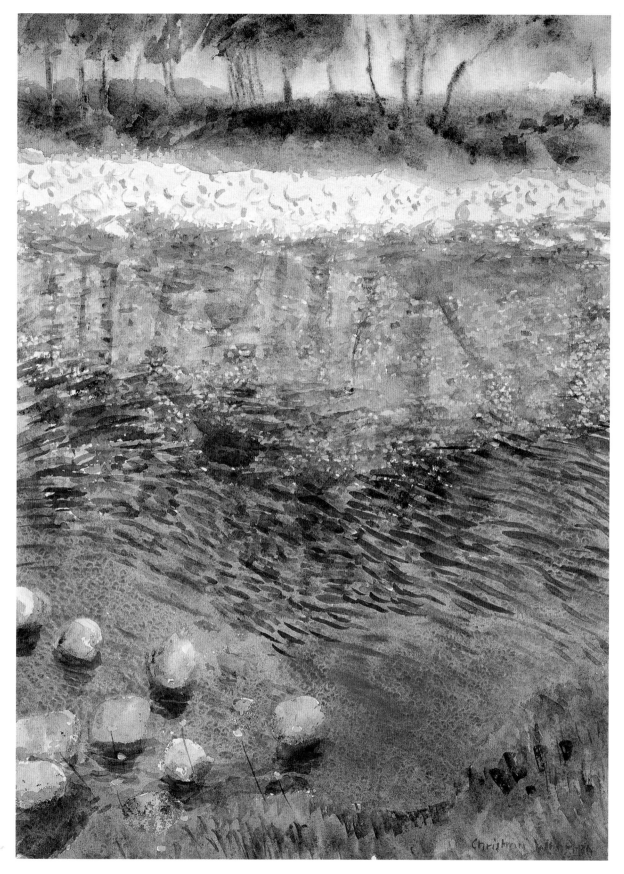

**BUTTERCUPS ON THE RIVER NEVIS** 76 x 56cm (30 x 22in)
The buttercups in the foreground were done with masking fluid, and I used a sponge to lift off paint from the underwater rocks. The pebbles on the far shore were done with very small brushmarks. I kept the trees rather loose and hazy, as they were lit up from behind by sun reflecting off the flanks of Ben Nevis.

65

# Rocks

Now we are getting closer to water!

Going back to what I said in Chapter 4 about contrasts, rocks play an enormous part in the credibility of a waterfall or river painting. The solidity and stability of the rocks are what counterbalance the fluidity and energy of the moving water. They are, quite simply, what makes it move.

Rocks are not easy to paint, and it has taken me a long time to get to grips with them. I make my students practise painting pebbles in the studio (something which John Ruskin also used to advise, but I thought of it for myself). There is a lot to be said for this, because it is always helpful to draw and paint from life.

But the trouble is that rocks in a landscape are very different from pebbles. They do not conform to simple, comfortable shapes. They are very often not light at the top and dark at the bottom. They can have light or coloured patches in all sorts of unexpected places, due to odd facets and pockets of different material or surface coatings of bright lichen, or even from light reflected from the water.

When you look at a rock it is three-dimensional, so the eye at once interprets it as a three-dimensional shape. But very often if you paint it exactly as it looks, it becomes two-dimensional, because it breaks the rules of form – unlike clouds, or pebbles, whose modelling is easy to paint and whose dark tones register the story of their three-dimensional shape.

## Rocks and energy

I was daunted by rocks for many years. But then I realized two things about them. One is that they have to be carefully drawn and understood. And the other is that on a fundamental level they are also composed of energy, just like water – so that they need to be painted with a combination of careful accuracy and speed. In other words, we are back to inspiration and organization once again.

**ROCK**
This sketch was made in charcoal pencil and the edges were smudged over with scrunched-up tissue.

In 1986 I went to a university in Iowa to start a master's degree in art. Iowa might seem an odd choice for a painter of waterfalls, but I went out there hungry for a better understanding of the underlying structure of matter as described by small particle physics, and knew that this university had an outstanding record for making this sort of knowledge accessible to other

**THE GOLD UNDERWATER ROCK** 56 x 76cm (22 x 30in)
I wanted to contrast the solidity and angularity of the rock with the fluidity of the ripples on the surface of the pool. I love the point at which the floor of the pool gradually becomes dominant. I painted this picture from memory and imagination.

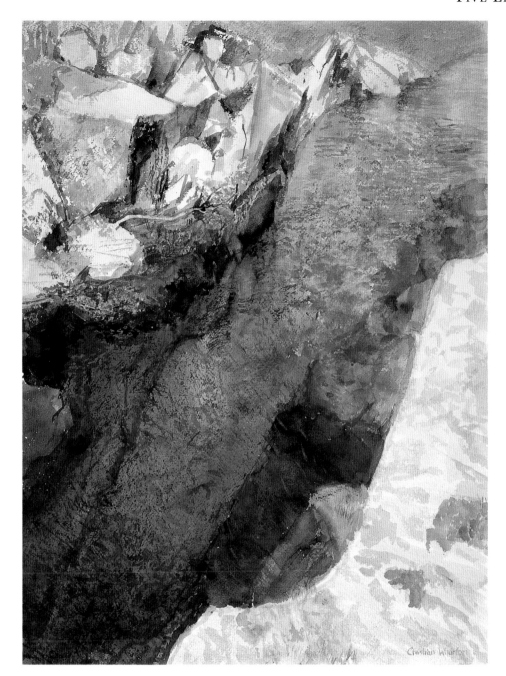

**BLACK MOSS POT, WHERE THE BECK FLOWS OUT** 76 x 56cm (30 x 22in)
This is at the point where the water becomes shallow enough to paddle in. I wanted to emphasize the lovely shape of the water as it flows from bottom left to the top right-hand corner, so I simplified the rocks in the bottom right-hand corner to make them read as a single, rather abstract shape which framed the dark water. I used washes for the water and afterwards added in touches of magenta with the side of a square brush to give the texture of the pebbles at the bottom of the pool.

disciplines. I felt that physics could shed some light on the whole meaning of art.

My hunger satisfied, I was able to get my intellect around some of the more advanced theories of the Unified Field (at least I thought so at the time – I'm not sure I could explain them to anyone now). I did sort out my ideas and I was able to do a lot of painting. As an additional bonus, I received a valuable piece of criticism.

It was tactfully prefaced by my tutor. 'Christian – I just love the energy in your paintings, and the colour, and the compositions…' Oh God, I thought, what can be coming? 'But… the water just isn't wet.'

I looked at the paintings in question. She was absolutely right! There were so many things to focus on, I had missed out on the obvious and vital fact that water should be wet.

I gave the matter considerable thought and came up with no simple answers to the matter of making water wet, because it is a combination of different factors. But one of these is to do with the surroundings of the water – in particular the rocks. If the rocks are not hard, the water will never be fluid. If you miss out on the rocks, the water will just look like fluffing about, or loosening-up exercises – good fun, decorative maybe, but not real.

# Water

At last, the icing on the cake!

I shall say a good deal about the different modes and moods of water in the next chapter, so here are just a few general principles:

- Painting water should always feel easy and flowing. You have to learn how to go with whatever is happening on the paper. It is the one area of the painting where strain and effort show. It is important to learn when to stop.
- It is possible to paint water very fast, but not necessarily always to use wet or even damp paper. Sometimes good effects come from a dry brush used on its side.
- To repeat the point that I have already made about the other four elements, you must observe the tonal values very carefully.

## Judging tones

The reason I attend life-drawing classes every so often is the fact that in my sort of painting there is no need for accurate delineation of forms (except for the outlines of hills and mountains, as I have already said), and I fear that my ability to draw accurately is on the decline. On the other hand, what I spend my life doing is judging tones, for tonal accuracy is the lifeblood of my painting.

You can judge tones by looking at your subject with the eyes half-closed, which polarizes the tonal values. It is good to be patient and to practise exercises to develop your tonal judgement.

In some of the most blurred images we have ever seen – for example, the shots of the first moon landings – it doesn't matter how confused and distorted the outline is: if the tone values are roughly in the right places, you can read the form (see the top drawing on page 66).

**SUNSET, ORKNEY** (left)
28 x 38cm (11 x 15in)
In this quick sketch from life, I was attempting to paint an extraordinary cloud which appeared at sunset. I used lots of water, for speed as well as for luminosity.

**AN STEALL BAN** (right)
76 x 56cm (30 x 22in)
I used a lot of subtle tonal variation in the hills and sky above the waterfall, which is in Glen Nevis, in order to suggest the dramatic quality of the weather. It was raining heavily and there wasn't much light, so the water was quite dark.

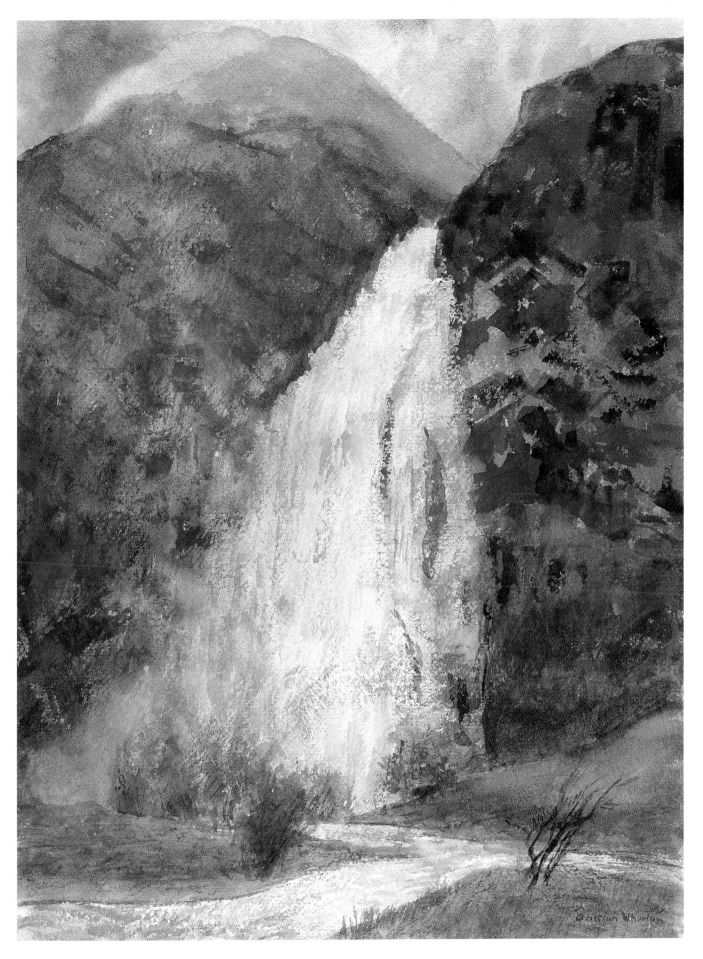

Christian Wharton

## Colour, tone and extremes

It is quite easy to get confused by the difference between notions of colour and tone. For example, black is a darker colour than red. But I have already discussed on page 60 that a red mailbox in the foreground could be darker than one in the distance. You have to free yourself from preconceived notions.

It is quite easy to judge the extremes – the darkest dark and the lightest light are not a problem. It is in the subtle areas in between that you have to develop this skill. This is what Monet could do superbly. In his old age his water-lily paintings were no longer done in realistic, impressionistic, colours, but in ones that reflected his feelings – in other words, they were expressionistic. But always he kept his superb judgement of tone, so that even though the water was painted in the wildest of colours, it always looked like the surface of water.

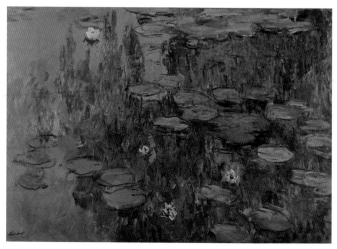

**WATER LILIES** CLAUDE MONET, 1918–21 Watercolour
In this painting, done at least ten years after the first, Monet used expressionist colours and a much looser style to convey the feeling that the scene gave him. But if you look at the painting with half-closed eyes, you will see that his tones are incredibly accurate within a narrow range.

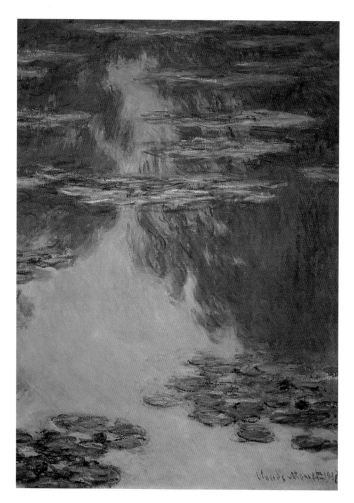

**WATER LILIES** CLAUDE MONET, 1907 Watercolour
In this painting, Monet was using impressionist colour – the actual colour of the scene before him.

## Tonal values: a colour painting from a black-and-white source

There are, unfortunately, no simple tricks or tips that can allow you to escape from the business of developing your own tonal judgement. But there are exercises that will help you. I make my students do a painting in colour from a black-and-white photograph, and suggest that you do the same. You will find that the result is surprisingly realistic, even if you have got the colours all wrong. It is also very good practice to transpose tone into colour – it gets you thinking in terms of light and dark.

You don't need a huge range of colours to describe effectively a variety of tones – I used my basic selection of paints (see page 31) and left the water as white paper. In such an exercise, each colour is added across the tonal range, rather than working from light to dark or vice versa.`

**THE SOURCE PICTURE**

1 To establish the very first shapes, lay in the foreground rocks using a mix of magenta and phthalo green, then dilute this for the top of the water, the arch under the bridge and the distant hill. Place the central long rocks as negative spaces between the trees, then go back and darken the arch and rocks below the bridge with a stronger mix before using blue for the top hill.

2 Use a mix of cadmium yellow and phthalo green for the trees on the right-hand side, then add more yellow for the bracken at the bottom in the green grass. Mix a colder green and show the direction of the trees above the water and rocks on the left, then while still damp, add magenta and draw in the lines of the trunks with the side of the brush.

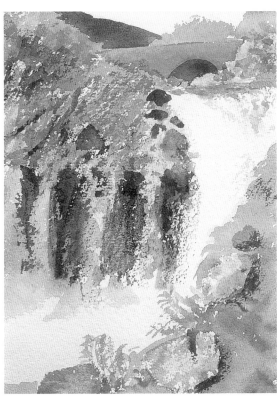

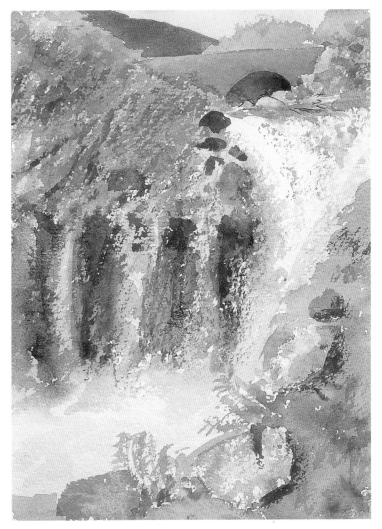

3 Fill in the bridge with a grey-blue mix, blotting back for variety of tone, then use a red-grey mix for the top of the water. Solidify the rocks with a darker mix, almost black, and use the same colour for the underside of the rocks at the bottom. Make a very pale wash by dipping the blackened brush into clean water, and use this for the shaded parts of the waterfall.

**THE FINISHED PICTURE** Add touches of yellow to the trees both left and right of the bridge, softening the edges and blotting out as you go. Use a pale diluted blue for the sky, then go over the water very lightly to suggest movement and the shadows created by the flow, using the large flat brush. Switch to a small round brush to put in the last details.

# Colours

The first principle about painting water is that tone is more important than colour. However, if tone were the only thing that mattered, we might as well paint all the time in sepia or black washes! Colour is, in fact, very important. It is especially important in expressing the quality of feeling. However great you are at tonal evaluation, there are some things in the painting that you are not going to be able to express.

If you examine closely, for example, a waterfall in the sunshine, you will find that its brilliance consists of a cloud of droplets, each of which acts like a small lens, with a highlight, as if it were a glass bubble or a small piece of chandelier crystal. Not only does it reflect the light, it also refracts it, breaking it up into tiny flashes of pure colour. (From what I have said already about pigment, you will know that it is difficult to paint a rainbow with the paints we have – it can be done, though, because waterfall rainbows are usually quite thin and not as brilliant as sky ones.) These little flashes of colour can be done with tiny strokes of pure colour: green, magenta, yellow and blue. They give something of the liveliness of the water.

You have to convey the brilliance in terms of colour, not merely tone, because it is impossible to paint a light source as it is.

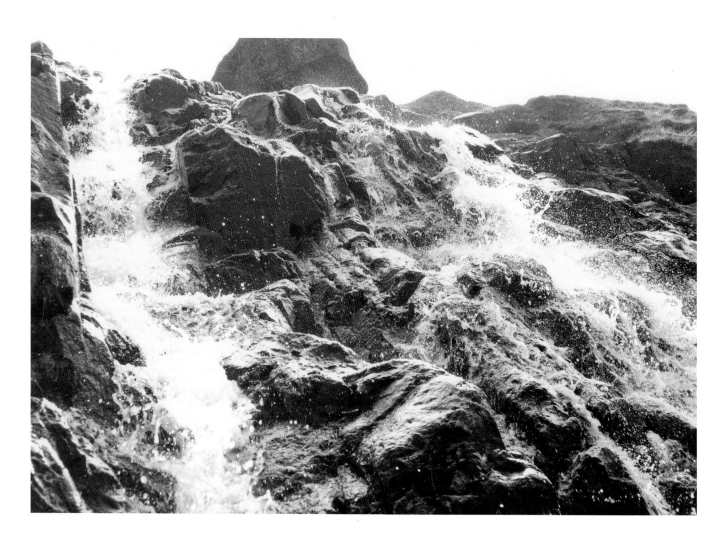

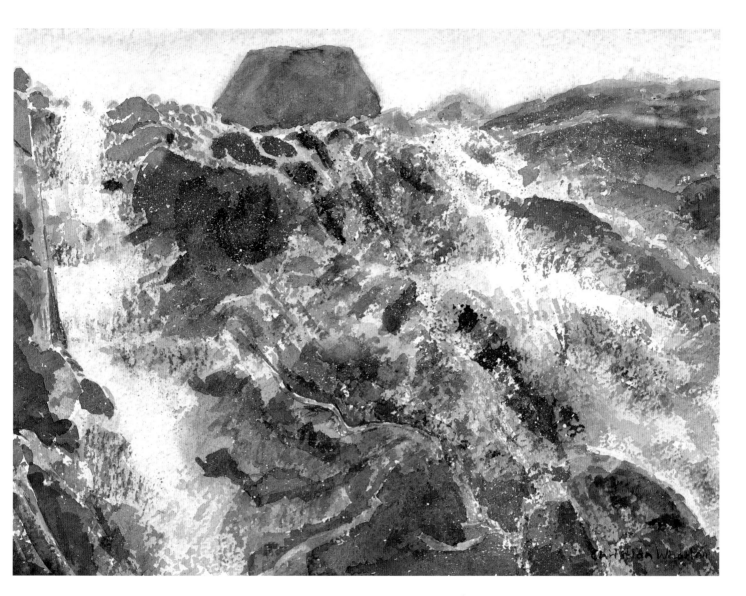

**GRAINS GHYLL** 28 x 38cm (11 x 15in)

When I went up this valley in Borrowdale the sun was setting. The water in this particular fall tumbles over a mass of hard, rounded rocks which fractures it into many strands, and kicks up a quantity of spray which, as I ascended, was caught by the last rays of the sun turning it gold and apricot, while the main body of the water was in shadow, blue and cold. It was enchanting, like dancing in a glass of champagne. I knew I had to paint it. But how to preserve the information? I could not sketch it – the light was changing too fast, and anyway my clumsy pencil could not convey the delicate, ethereal quality of the clouds of spray. I took photographs (left), but when I saw them, they were such an anticlimax after what I had experienced that I put them away in a drawer.

Two years later, I had another look at the photos. I realized that although they did not convey the experience or the feeling, they did give the bones, or rather, the anatomy of the composition. The rest was inside me. All I had to do was to paint from the feeling level. So I did a series of paintings.

For this new version I used lots of spattered masking fluid as well as drybrush work. I also used reds and oranges in the water to express the feeling of the gold mist of spray

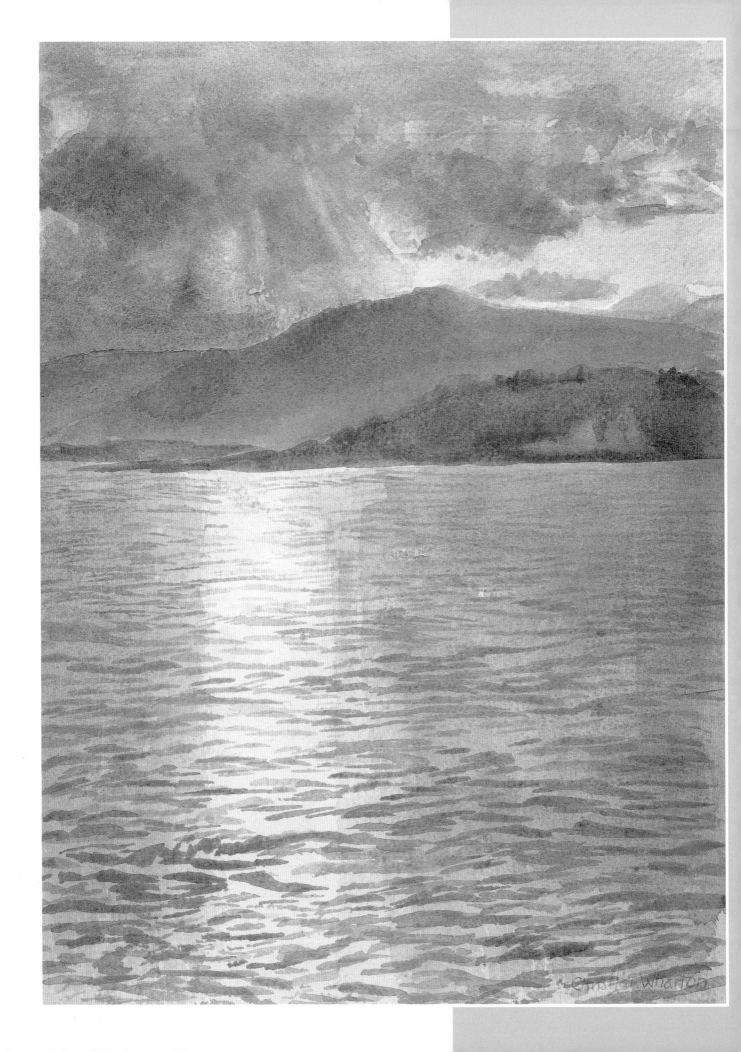

*'Sabrina fair,*
*Listen where thou art sitting*
*Under the glassy, cool, translucent wave…'*

*John Milton*, Comus

# chapter 6
# The infinite variety of water

It is a platitude that water comes in all sorts of shapes, sizes and moods. This chapter is about some of them – if by no means all. My water paintings are not restricted to waterfalls, but include riversides and pools, shallows and deeps, and, of course, the sea. Here are some descriptions and advice about these categories, ranging from the calmest of the calm to the wildest of the wild.

**SUNSET AT THE CORRAN FERRY, LOCH LINNHE**
38 x 28cm (15 x 11in)
The sea was painted in several stages: I put a wash over the whole thing, and when it was dry put another wash of a darker tone either side of the reflection of the sun. I then added the ripples with delicate brushstrokes and finally added some more colour to echo the variations of colour in the sky.

# Still water

With still water, be it the surface of a lake on a calm day, or a smaller, secluded pond, it is necessary to look carefully at the perspective of the reflection. If you think of the surface of the water as like a mirror, it will only give a perfect mirror image if your eye is almost on the surface of the water. When you look down onto a lake, the image of the reflection will be distorted and truncated from the top, so that it will never be the complete reversal of the view above the water.

The other thing to remember is that the tones will not be quite the same, either – the ones in the reflection will be closer and slightly darker because the water is coloured by what is underneath it. If you think of the surface of the water as the glass of a mirror, you have to remember that there is no silvering behind it. However, the deeper it gets, the better it reflects. You will have noticed how the reflections in very shallow pools are hardly perceptible. The general advice here is to look very carefully at your source material, whether you are painting from life, or photographs, and always to paint what is there, rather than what you think should be there.

**MIRROR REFLECTIONS**
The boat and jetty show that the viewpoint is well above the surface of the water. The image on the left is incorrect as you only get mirror symmetry when the vantage point is right on the water level. In the image on the right, the reflections look more distorted, but this is how it actually was.

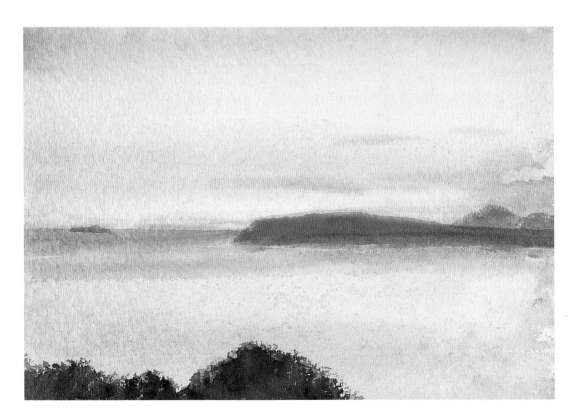

**DUBROVNIK SUNSET**
28 x 38cm (11 x 15in)
This is a quick sketch of a sunset over still water, using lots of run-in colour. I added the trees in the foreground once the other washes had dried, and deepened the colour on the distant islands.

# Lerwick Harbour

Run deep though they may, still waters are as much shown by the other parts of the landscape around them as through their own efforts – this view of the waters of Lerwick Harbour in the Shetland Isles is defined and put into context by the harbour wall and boats.

**PRELIMINARY SKETCH**

1 Using a strong mix of ultramarine, find the outline of the column and jetty on the left and in the background, blotting the washes until just the shapes remain. Add a green wash for the far strips of land and a very pale blue for the distant hills before indicating the shapes of the buildings on the quay.

2 Use a pale blue-green wash to start the ripples on the lower part of the paper, then add magenta for the darkest steps and the detail on the far buildings. Use a flat brush to make big washes for the column, and to make wet-in-wet suggestions for the stones on it. Switch to a round brush for the ripple reflections, then wash in the yellow sand and magenta shadows.

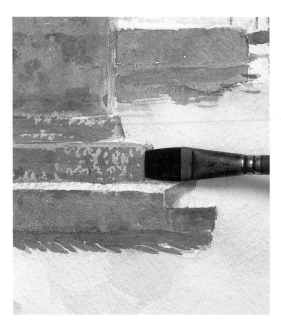

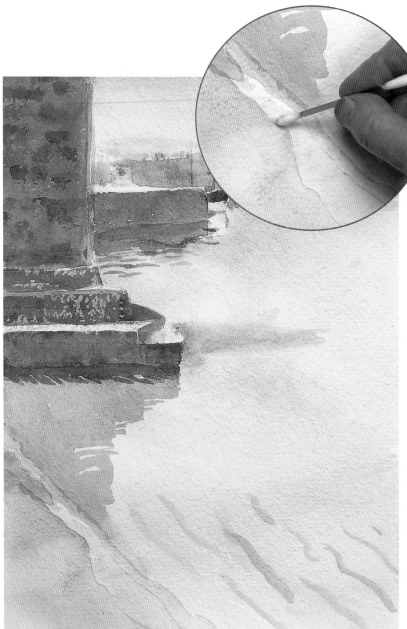

3 Add the darkest tones of the shadows on the steps, and use dark ultramarine for more stones on the column. Start to draw the boat by the quay with the tip of the round brush, then switch to the flat brush to wash-in diluted ultramarine for the sea, dabbing back with a tissue. Add the pale sky. Drag a brown-blue wash very lightly over the paper to capture the texture.

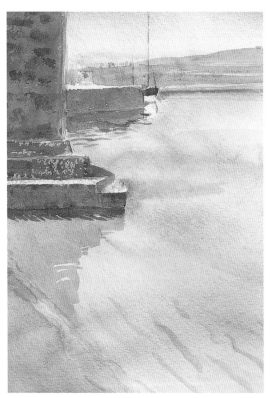

4 Build up layers of bright blue beyond the quay and for the reflection from the steps, then add green for the ripple reflections and the far right-hand hills. Make a green-yellow mix for the shadow between the steps and sand. **Inset:** To soften hard edges, even on dry washes, apply water with a clean brush and gently rub with a cotton bud or swab.

5 Move through the colours of the water – yellow foreground washes, and blues and greens in the centre – then build up the wettest areas of sand with a mix of magenta and blue. At this stage, it's worth looking at the whole painting in a mirror to re-evaluate and check your tonal and colour values, and amend and strengthen the shades as required.

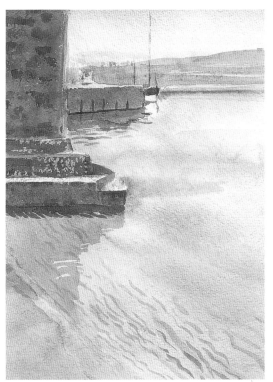

6 Put in some green-yellow ripples, giving the impression of a mass rather than trying to capture each one, then switch to blue for the further ones, dabbing them almost dry to avoid hard edges. Shape the quay buildings and fill in the road surface. Working with the very tip of a round brush, add the dark battens on the quay and their reflections.

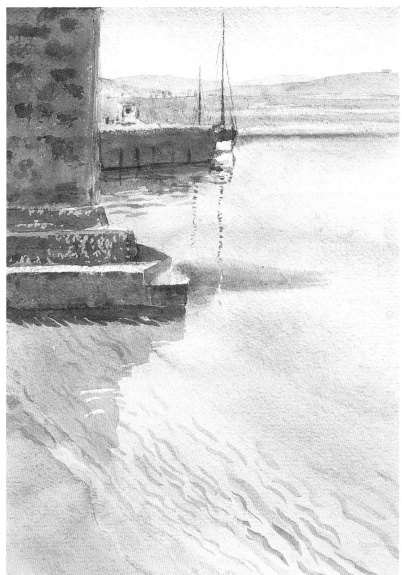

**THE FINISHED PICTURE** Now concentrate on the finer details – the masts and rigging on the boat and the reflections on the bottom of the hull. Brush in the reflections of the masts, using the rough paper surface for texture. Suggest the buildings with dark washes, then finish with a little body colour or gouache white to add a few sparkles on the water.

# Pools

Pools are some of the greatest loves of my life. You might think from what has gone before that it is white water, but quite honestly, I can't say which is my preference. Pools are an opportunity for developing colour, as well as for the exploration of delicate layers beneath the surface.

I have always loved layered images. In the transformation scenes that featured in the pantomimes of my youth, a chorus of villagers would perform a jolly dance in front of a backcloth painted with a solidly constructed village. Then gradually the lights in the front would dim and the village would be revealed to be on thin gauze as the lights began to light up the enchanted castle and the trees behind. (There is something so wonderful about magic that can be clearly explained.) But, for me, the most magical moment was when that half-revealed castle appeared behind the transparent village. This is what pools do – both the surface and the depths are visible at the same time. The only alternation is between which is dominant.

## Light under water

In Chapter 2, I made the point that when you are painting water you are, in effect, painting light, because most of what you see is the reflection of light. But when you paint pools, you have the added bonus of looking into the depths and painting light under water.

I first saw the Black Moss Pot in the Langstrath valley in Borrowdale long before I had any interest in painting water. It struck a chord with me then, and in recent years I have been back many times and done a series of paintings of it. I think it is one of the wonders of nature – that is, when the sun is shining. When it is not, the pool looks dark and rather sinister.

The Langstrath Beck is a little river that runs down a long, straight valley into a natural fault about 10m (30ft) deep. The water is slightly blue, possibly due to the vein of copper in the area, and the surrounding

**SNAKE IN A POOL** 56 x 76cm (22 x 30in)
This is a portrait of my neighbour's boa constrictor, and although I do not like snakes much, in the course of painting it I began to appreciate its beauty. I used the patterns of the water to echo the patterns of the snake's skin. Because it was an unusual subject, I also used wax to give the texture of the skin.

rocks are a jumble of cream and dark grey. The pale rocks take on a gold colour when they are under water, and as the water gets deeper, this becomes the most magnificent of greens, the dark ones becoming deep blue. The water is absolutely clear and you can see the rocks and stones on the bottom which come in many sizes and colours, as well as wonderful patterns of sunlight that fall through the ripples onto the bottom.

Even in sunlight, this place can have a variety of moods. I saw it twice within the same week in a dry June. The first time, the effects were as spellbinding, but the clouds were capricious and prevented any successful photographs. The second time was a perfect, cloudless sunny day. But the water in the beck was running lower due to drought, and there were no ripples in the pool – the network of golden lines playing over the rocks on the bottom was gone. Fortunately, mankind came to my rescue in the form of swimmers, who brought back the ripples and the golden net (see front cover).

## Ripples and prisms

The shimmering, golden net – never still, always vibrating and changing – is fascinating. The ripples on the surface of the water become prisms and refract the light

onto the bottom, so that what appears is a concentration of light that forms a line that roughly echoes the movement of the ripple. As the light is refracted it is also broken into its component parts, but you do not see rainbows, only small splashes of pure colour at the edges of the gold lines. I call them lines for want of a better word, but the more you look at them, the more you realize that they are not lines in many of the accepted meanings of the word. They flatten out at will, becoming wide, broad and diffuse. They are really more like a skein made of twisted filaments that twist and untwist at will. The light travelling along them is not consistent – in some parts it is much brighter than in others, particularly where lines intersect.

It is one thing to observe these lines at the bottom of a flat swimming pool – quite another to look at them below the surface of a rocky pool. The rocks cannot be painted exactly as they are; the technique is to make accurate tonal representations of a sufficient selection of them, and this gets easier with practice.

## Layers and reflections

On the surface of a pool you get reflections of the sky and surrounding banks and foliage. Depending on the quantity of light and the depth of the pool, either the surface will dominate, or the bottom – the strong light

being a bit like the light behind the gauze drop in the pantomime scene. On a cloudy day, however, the surface dominates and the depth of the pool makes the shadows dark and gloomy.

There is another thing about reflections in pools. Where the sky is being reflected, you will see less of the bottom – it will look as though a thin, opaque blanket covers it. But where dark objects such as trees or rocks are reflected, you get a much clearer view of the bottom.

Shallow pools behave the same way as deep pools, but have a narrower tonal range. You have the same alternations between surface and bottom, but they are always both clearly visible – it is just that one or the other dominates. So you have to observe the subtleties very carefully.

## Textures

The Black Moss Pot is a long, narrow pool. This is another of its greatest advantages. It is always still at the shallow end where the river leaves the hole. If you feel defeated by the complications of the ripples, you can always start with this bit. I did (see page 83).

**APPLYING THICK PAINT**
I applied the paint with a dry brush rather quickly, to give the impression of the light coming through.

The consideration in pools is how to get the texture of the silvery rocks and stones on the bottom without painting in every single one. The two textural techniques that I use are building up thick paint with a dry brush, and working the paint with heavy pigment so that it falls into the hollows of the rough paper.

Getting colour into the hollows is challenging, because the results are unpredictable. So often I have dropped in heavy pigment onto wetted paper and it has done exactly what I want, only to find that when it dries, the stippled effect has gone matt. The trouble is

**HEAVY PIGMENT FOR TEXTURE**
Here, I painted the rocks on dry paper with a mixture of cadmium red, cadmium yellow and ultramarine blue. I then made dark lines using the same mixture, with the additon of lots of blue for the outlines. Finally, I overwashed with phthalo green.

that heavy pigment doesn't really want to stay in place. It wants to travel with the water as the water spreads over the surface until it can form a shoreline where it meets dry ground, like flotsam and jetsam.

Ultramarine is a good colour for dropping, as is cadmium red, so I use those to make a dark colour. I put a thickly loaded brush on dry paper and then overwash with phthalo green, which has the effect of driving the pigment into the hollows. I also wait until the wash is almost dry and then sponge out some of the highlights with a folded tissue.

In any pool, shallow or deep, the side of the ripple that reflects the shadow exposes more of the floor of the pool. This is because the reflection of the sky makes the water more opaque. If you get this right, your water will instantly look wet.

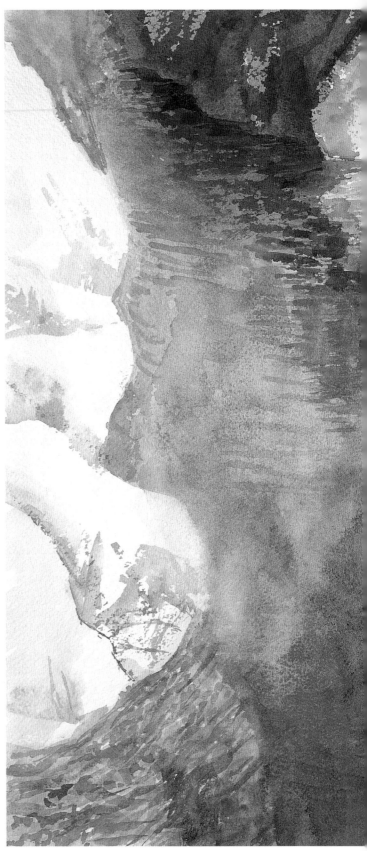

**TONAL STUDY**
I kept the tonal range very narrow in this study of a shallow pool. The interesting thing is that where there is a reflection, the outlines of what is under the water become much clearer.

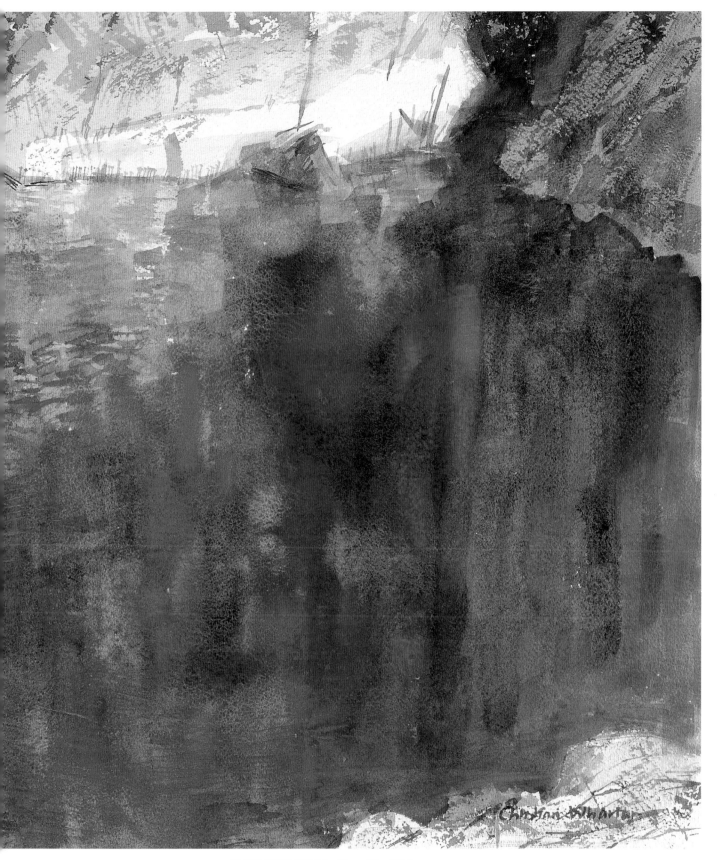

**BLACK MOSS POT** 56 x 76cm (22 x 30in)
I used the contrast between the pale rocks on the left and the blue of the water to enhance the impression of light. The rocks at the back were done with lots of drybrush work. For the pool itself I laid in massive strokes with a broad, square-ended brush with lots of ultramarine, phthalo blue and phthalo green. I used magenta throughout the painting to highlight and emphasize the greens.

83

# Black Moss Pot

This view of the Black Moss Pot, looking straight down from the rock in the foreground, is all about the play of light and the patterns it creates on the different surfaces. In this exercise I put down some of the darkest colours first, then washed over them with lighter hues to move and soften them for a watery effect.

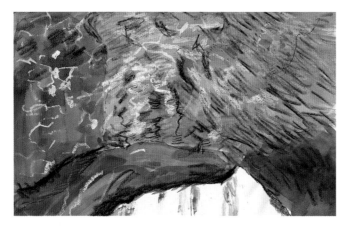

**PRELIMINARY SKETCH**

1 Use the tip of a round brush and a very diluted yellow wash to map out the lightest areas, made by the water acting as a lens for the sunlight. Work carefully, dabbing the wet paint with a tissue, and look for changes in colour and intensity of brightness. Set the shapes of the top and right-hand areas with pale blue-green marks.

2 Use a blue wash to add the dynamics of a strong contrast between the lightest and darkest tones, then add a few green ripples on the right. With magenta added to the blue, find the brown of the foreground rocks and the ridge where these meet the white at the bottom, and add yellow around this area. Soften any unwanted hard edges with clean water.

3 Use the flat of a flat brush to lightly lay diluted magenta over the white rock, then with the same technique, wash a strong blue over the shadow area bottom right, always following the ripples and movements in the water. Leave the sunlit areas as negative spaces, and work across the whole water area with a light green wash.

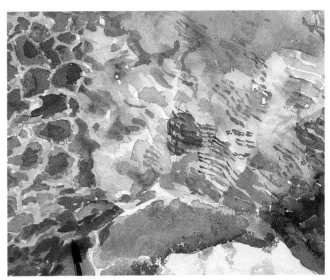

4 Build up the darker tones on the right shadow area using blue and magenta to find the shapes of the water and rocks. Add light washes over the darker ones around the lighter areas near the top. Use washes of ultramarine and magenta for the dark left-hand rocks, then reinforce the yellow and green light and reflections across the whole picture.

5 Wash diluted magenta and red over the foreground rock, and strengthen the mix for the shadows and dark ridges nearby. Add pale blue washes from the top down, looking for tonal variations rather than covering everything. Use the tip of a round brush to apply bright red wet-in-wet with ultramarine for the darkest areas, then go over most of the remaining whites on the left.

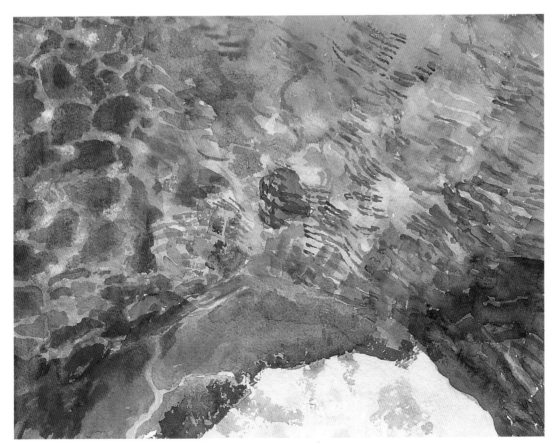

**THE FINISHED PICTURE** Add more blues and greens with the round brush to continue the movement of the water, lifting out too-strong colour with a tissue or cotton bud. Use a very dilute green wash (or even dirty water) over the left-hand side to pull the rock colours across, dabbing these to lighten them and create highlights. Finish by defining any last details.

# Rivers and ripples

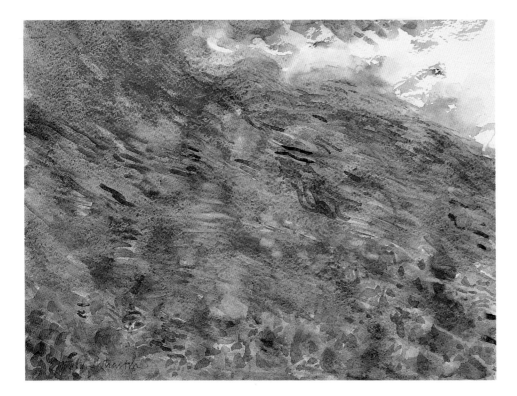

**POOL, LANGDALE** (left)
28 x 38cm (11 x 15in)
I did a series of studies of this pool, experimenting with different colours and ways of conveying the energy moving through it, as well as showing the rocks. All the whites were done with reserved paper. I also lifted off colour with a square-ended brush to make some of the light ripples.

**LANGSTRATH BECK** (right)
76 x 56cm (30 x 22in)
Even a slow-moving river creates a myriad of ripples and movement, and you have to look for a variety of ways to capture these; here, I combined both pale and dark washes and flat brushmarks, lifting off wet paint to create light and shade.

**USING A SQUARE-ENDED BRUSH**
I used the tip of a 25mm (1in) flat brush to make small marks, working from fully-loaded to drybrush, then combined these with longer sweeps and gentle side-to-side moves. I used these all together in 'Pool on the Croe' (see page 21).

It is impossible to think of ripples without thinking of the Impressionists who painted them so beautifully. They painted in oils, which gave a slight advantage because the brush can naturally make a ripple with a small jab – if you attempt this with watercolour, you end up with a small jab with a dark line round it. The answer to this is to use very slightly dampened paper.

Ripples tend to be banana-shaped or rather, like a banana that someone has tried to flatten. They are not difficult to paint, and you could almost paint a scene of willows hanging over a river from imagination, with the aid of a square-ended brush.

Painting rippled reflections is not hard – just a matter of getting the tones right, which is not difficult if they are far apart in the first place. It gets more challenging when the tones are closer together and when you can see what is under the water through the darker tones. *Pool on the Croe* on page 21 was like this. It took a lot of work to get the tones correct because at every part the balance between them was different.

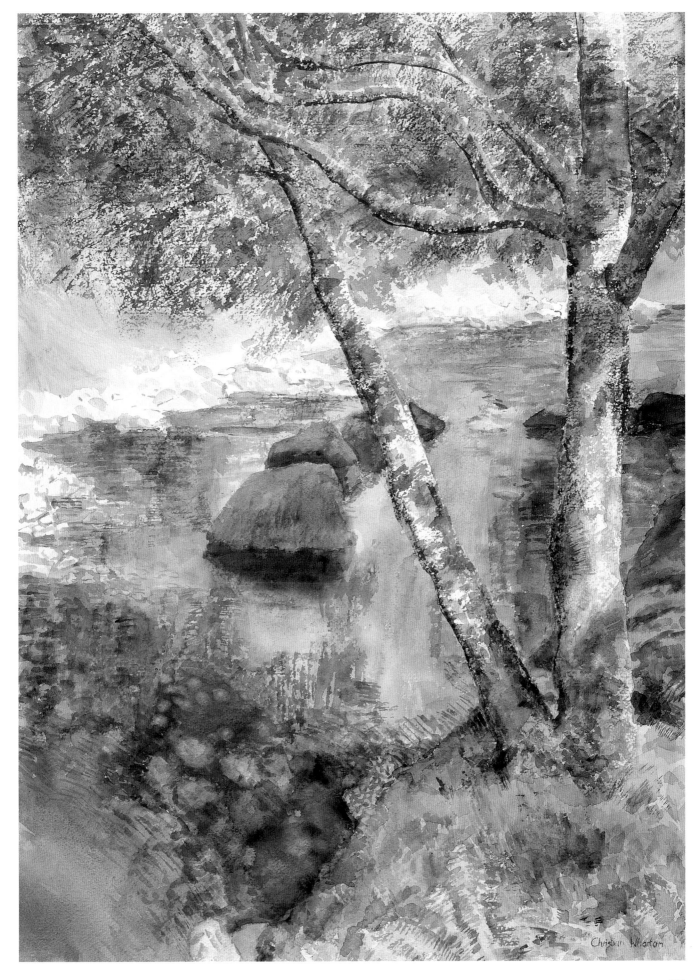

Christian Wharton

# Langstrath Beck

Every part of this little river is marvellous to observe, and it repays visits in all seasons – I chose a view in high summer, when the play of bright sunlight on the water, rocks and overhanging foliage is at its finest.

I used my regular range of colours – cadmium yellow, cadmium red, ultramarine, phthalo blue, phthalo green and permanent magenta. Three brushes were used: a No 12 round, and 25mm and 12mm (1in and ½in) flats, on heavy Rough paper. Always test the colours on scrap paper before applying them, as much for the feel you want as for the 'accuracy'.

**PRELIMINARY SKETCH**

1 Dab the flat of the 25mm (1in) flat brush to start finding the texture of the rocks, just touching the bristles onto the high points of the Rough paper lightly. Add the main overhanging branches with a brown mix, and use the tip of the brush to put in the cracks and separating lines onto the left-hand rocks.

2 Use the flat of the brush to find the shadow areas in the water – to achieve varied colour and tonal effects at this stage, put different colours on different parts of the brush. Still working with the flat of the bristles, apply diluted blue-green mixes, lifting off the paint with a tissue to leave just a very light stain on the paper. Use the same method to lay in the basic greens of the foliage, interspersing these with a stronger yellow.

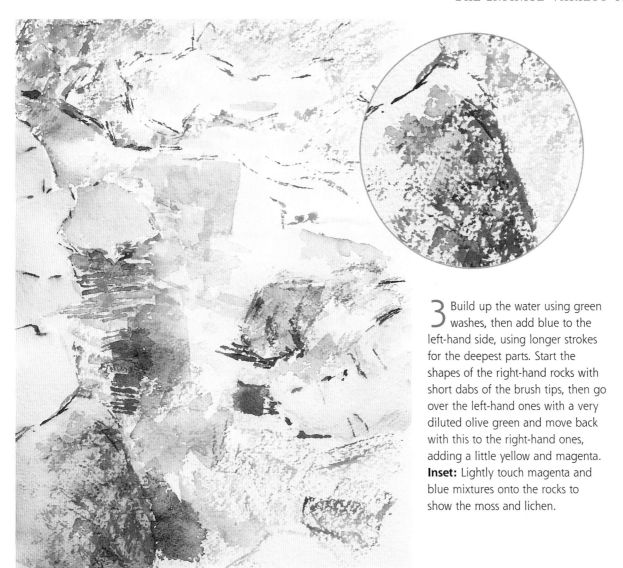

3 Build up the water using green washes, then add blue to the left-hand side, using longer strokes for the deepest parts. Start the shapes of the right-hand rocks with short dabs of the brush tips, then go over the left-hand ones with a very diluted olive green and move back with this to the right-hand ones, adding a little yellow and magenta.
**Inset:** Lightly touch magenta and blue mixtures onto the rocks to show the moss and lichen.

4 Go through the colours to slowly build up depth and solidify the rocks, using dark lines to create the form and contours. Add the ripples with the brush tip, and deepen the water with green and yellow washes. Keep the foliage light by lifting off light touches of ochre and green with a tissue.

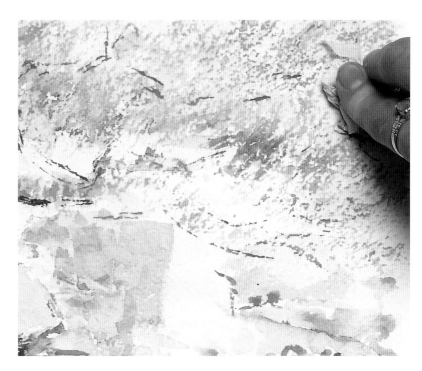

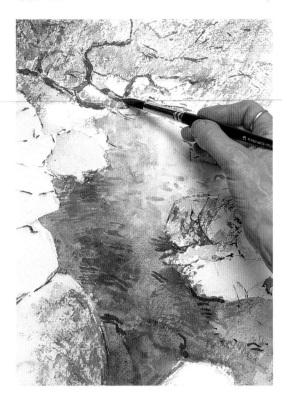

**5** Use the tip of the brush to mark along the branches, then thicken them. Use stronger mixes of blue and green in the left-hand stretch of water to show the cast shadows. Use the No 12 round brush and a dark blue mix to shape the foreground rocks and build up the ripples. Give definition to the cracks and fissures with a blue and magenta mix, using the white of the paper as negative shapes. Add dark yellow and ochre to define the rock undersides, then apply a dark red-brown for the undersides of the branches.

**6** Soften any unwanted hard edges with a sponge and clean water, then scumble a diluted purple-grey for the effect of dappled light on the middle left-hand rock, lifting out the paint to keep the soft edges. Add the finest lines across the whole picture, and then spread a mix of yellow and red across the lower left-hand rock.

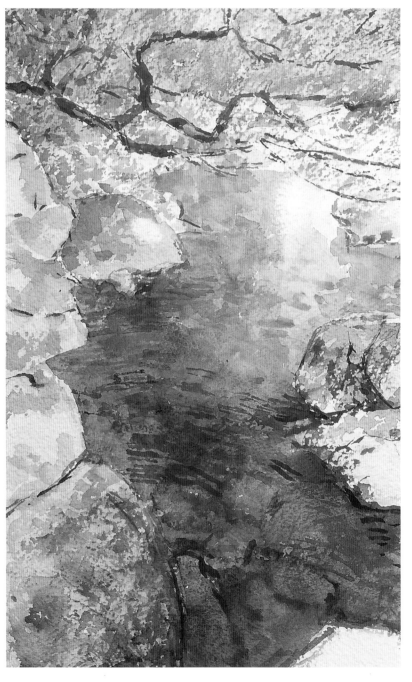

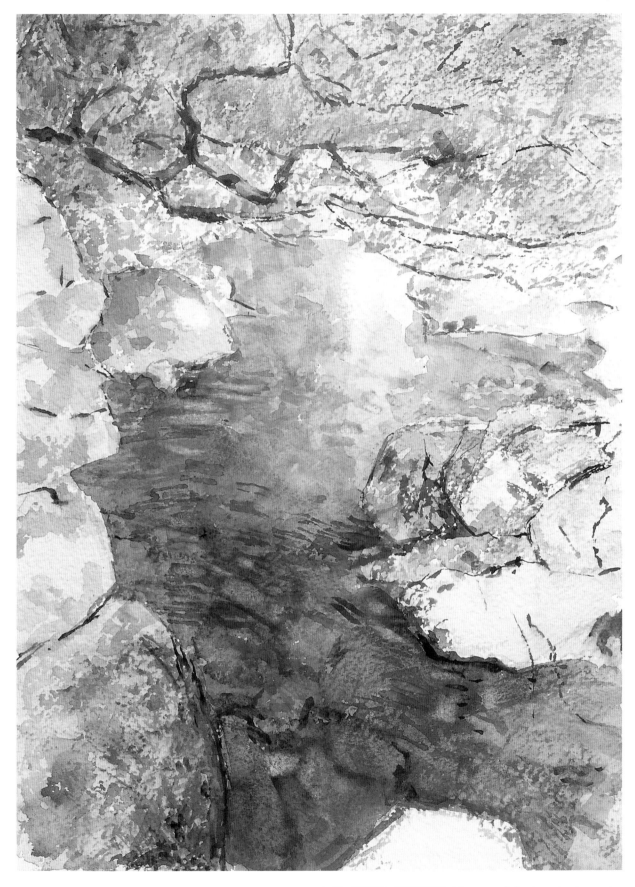

**THE FINISHED PICTURE** After overnight thought, I toned
down the shrillness of the leaves with light red washes, and
lifted out the darkest parts of the water.

# White water

The thing to remember about all white water, whether it is small rapids in a stream or a vast epic waterfall, is that it is never completely white.

It is not flat white, but neither is it dark. Because we cannot paint light itself as it actually is, the lightest of the light can only be the reserved (or masked) white of the paper. It is good to remember here that the lightest light need not be white, only the lightest thing in the picture – even at night snow looks white, though in actual fact it is dark grey.

## Getting the tones

All the movement of the fall, the delicate shadows made by the chunks of froth, as well as the transparent sections as it falls over rocks, have to be painted in light tones. When you have got the tones correct in relation to each other on the face of the waterfall, then you have to look again. You very often find that the curtain of seemingly brilliant white water falling towards you is

**WILD WATER, BHUTAN** 28 x 38cm (11 x 15in)
I painted this study of the rapids on a glacial stream almost entirely with the flat of a square brush, moving it very rapidly so that the paper threw off the paint to give a white gleam. The rocks were done with thin wet paint which was allowed to run in. I emphasized the dark behind the rocks at the back to give a sense of distance as well as to frame the white water.

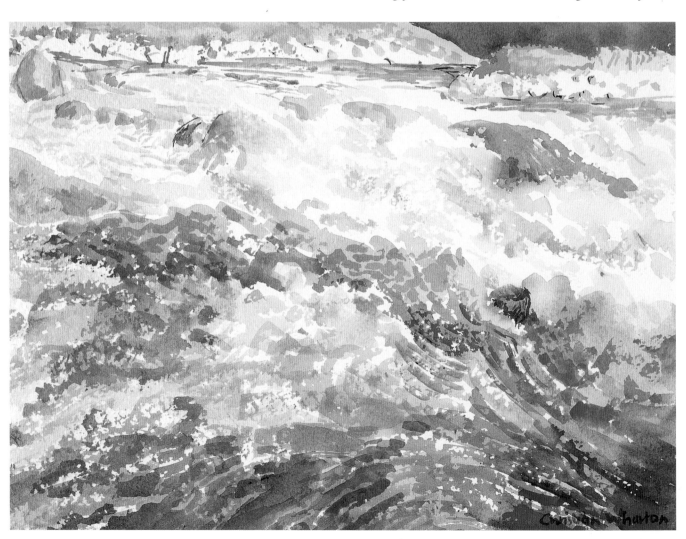

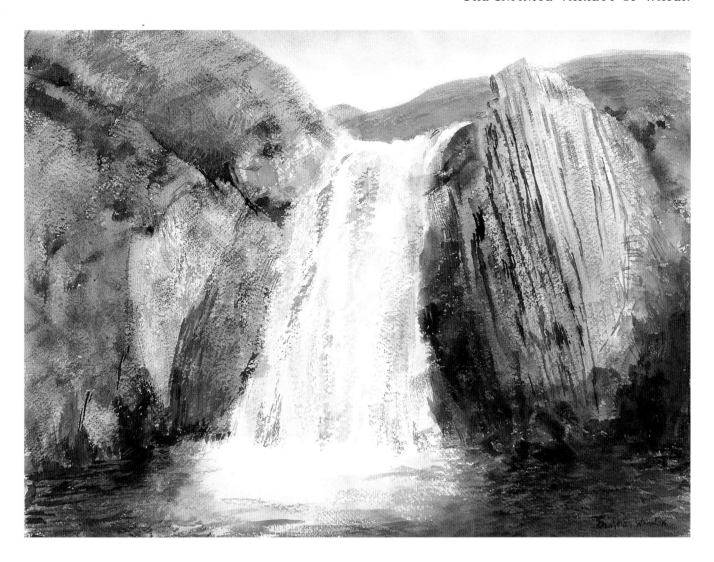

**AITH FALLS, SHETLAND** 56 x 76cm (22 x 30in)
I emphasized the diagonals on the rocks to the left of the falls to contrast with the direction of the water. I also used small touches of magenta in order to connect the two sides of the painting – I wanted to suggest that there is as much energy in the rocks as there is in the water.

in fact in shade, and the lightest part of the fall is the foam at the base, and the top where it breaks over the cliff. What do you do in these circumstances? Well, you paint it as it is and put a wash over the whole carefully painted face of the waterfall. Because you have preserved the tone ratios correctly, the overwash just puts the fall in its place in the landscape where it belongs.

Heavy, Rough paper welcomes the brush. I work fast with the brush on its side. There is much more horizontal and diagonal movement than appears at first – this is what the brush is so good at. But because the water is the lightest thing in the painting, it is not good to disturb the paint too much after you have done it. Chapter 7 is about correcting mistakes – heavy paper allows for a lot of alteration – but rubbing and scrubbing does damage the surface of the paper, and shows up in a light area. The water should always look effortless.

The other thing that comes with practice is to learn how to use the accidents to your advantage. If colours run which weren't meant to, maybe there is something that you can use in that situation. Remember that rapidly falling water is never the same for more than one second. There is a certain amount of flexibility. Having the correct tonal ratios does not mean having the tones in exactly the same places as they are in a photograph. When I did the first High Force paintings I used 19 photographs, each of which made the water in the fall quite different. I had to choose which was the most dramatic. Now I know enough to be able to create from memory without have to use so many photographs.

## Waterfall in spate

My most recent High Force paintings have been of the waterfall in spate, with water coming over the top of the large central rock. This is something that doesn't happen very often, because a lot of the water is taken by a reservoir further up the valley. Then in 2000 there was a tremendous flood, and I knew the water would be 'over the top'.

The scene was changing every second as great waves of water built up and crashed over the rocks on the larger, left-hand fall. The right-hand fall was now as dramatic as the other, and the rock in between no longer kept them apart but was conquered by a cascade of white over one section.

The spray built up into drifts that wandered like ghosts across the basin between the cliffs, and there were subsidiary falls everywhere on the cliffs and on the approaching paths. Every so often there was a huge wave and a surge of spray that almost obliterated the left-hand fall. The water below was churned up into large waves that reminded me of Niagara.

But there was very little light and very little tonal variation. In my previous paintings of High Force, I used the massive darks of the cliffs and the central rock, to emphasize the majesty and power of the falls. Now the waterfall was in spate this was not possible because almost everything – including the water – was grey. So I had the task of conveying it with a narrower tonal range. This is why I put more light in the sky in this painting, with a sulky sun trying to peer through the cloud.

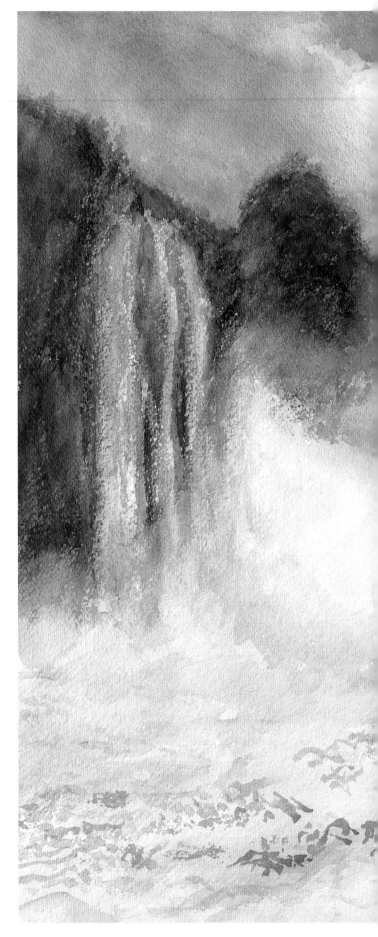

**HIGH FORCE IN SPATE** 56 x 76cm (22 x 30in)
I kept the foreground very light to indicate the huge masses of water in the waves. This was a painting which just went fast by itself.

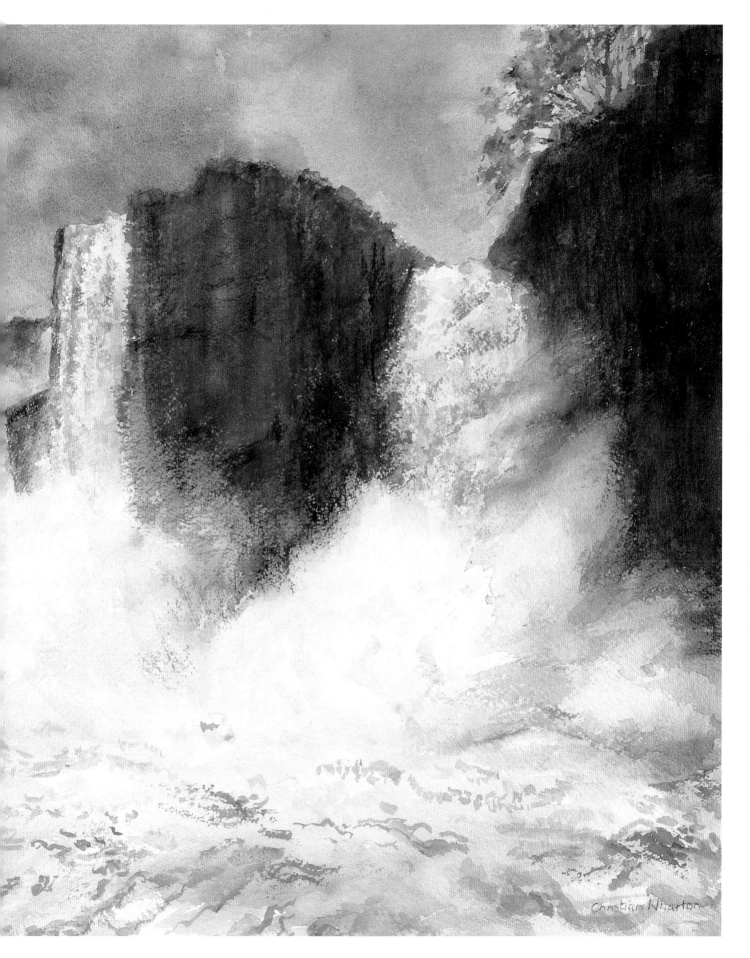

Christian Wharton

# The American Falls, Niagara

For this painting of the American Falls at Niagara, I had to make a decision about what to include – everything? The left or right sides only? In the end I chose to compress the view from the photograph, bringing the left-hand bank closer into the composition, which kept the dynamism without losing the scope.

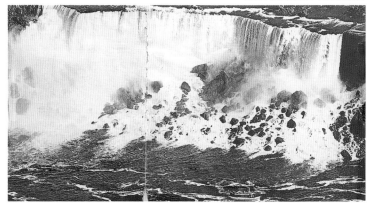

1 Very lightly shape the cliffs on either side and the top edge of the water with very diluted blue, then position the central largest rocks. Add the darkest tones using a mix of cadmium red and phthalo blue before filling in the right-hand rocks. Repeat on the left cliff, leaving areas to suggest forests and trees.

2 Darken the original rock marks with varying strengths of magenta plus phthalo green and cadmium yellow, looking for the light and shade in each one. To give the feel of falling water and foam, just touch the top of the paper surface with the brush, and use this same method with pure blue for the darkest parts of the falling water.

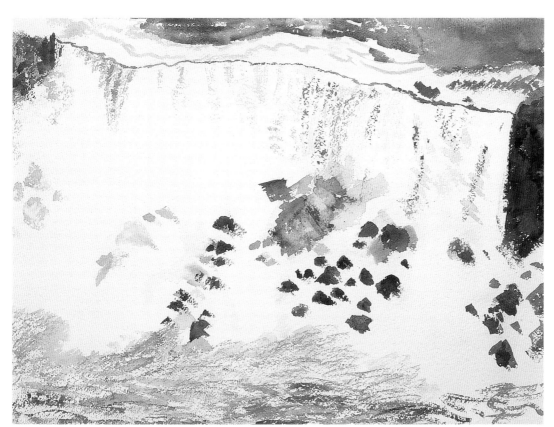

3 At the top of the falls, work around the movement of the negative white foam shapes with diluted blue, then use the tip of a flat brush to add the darker blue-green of the hairline water's edge. Add the blue water above, drawing the edges and blocking in the colour, and scribble green movement marks at the bottom.

4 Use blue and green to reinforce and darken the top rapids, blotting off excess wash to create tonal variations, and building up layers rather than adding solid blocks of colour. Add more rocks in the magenta and blue mix, and when dry, use an old fine brush and masking fluid to mask off lines of foam in the foreground.

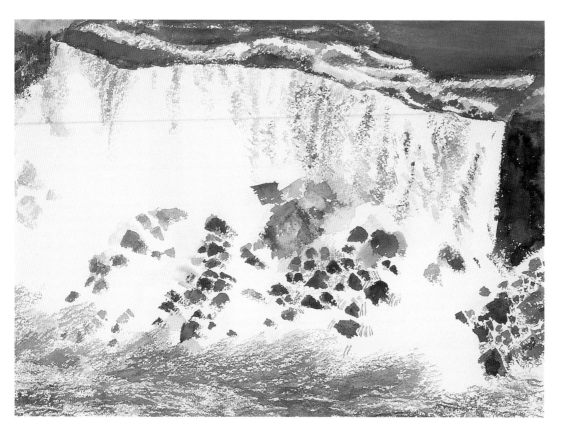

5 Mix blue, magenta and green for the shadows in the foam above the falls edge, and to strengthen and darken the central rocks. Make directional marks for the water at the bottom, working drybrush for the texture and going over the masking fluid, but still leaving white paper to show through as you build up the fall of water.

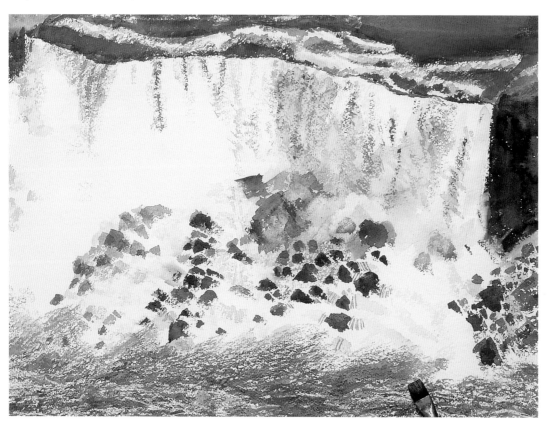

6 Apply very diluted blue washes for the spray coming back off the central rocks, blotting off the paint to give subtle gradations of tone. Use the same light mix for the movement lower right, then work across the whole of the falls, working slightly stronger blue into the vertical marks at the top.

7 Add more very diluted washes for the foam and shadows, blotting off and keeping everything very light on the left-hand side. Gently darken the central and right verticals, building up the colour by working drybrush. Add more washes over the foreground water, allowing the previous marks to show through.

**THE FINISHED PICTURE** With all the washes dry, scrape off the masking fluid in the foreground. Use a fine round brush to tighten up and darken the top of the rapids, and add the wave lines inside the washed-out foam areas. Finally, soften any hard edges on the lower waves where they meet the white of the falling waters.

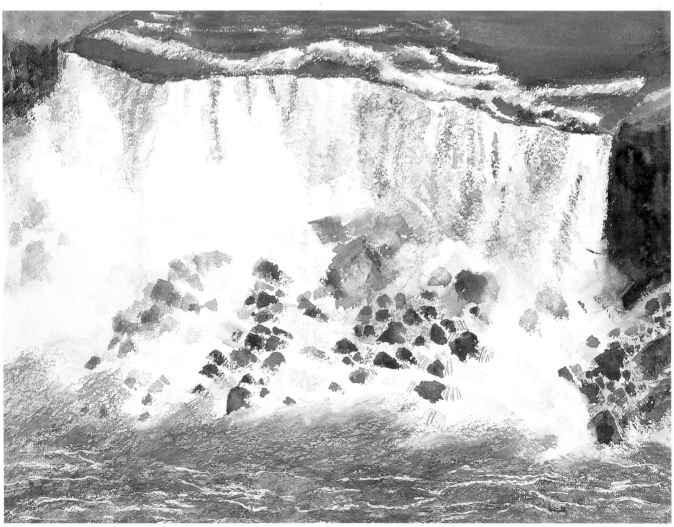

# Sea

It would be a lifetime's work to paint the sea in all its moods. My focused interests so far have included the shorelines of sandy beaches, rock pools, breaking waves and storms.

## Breaking waves

Breaking waves are a little more challenging than waterfalls because the water is going in all directions. Over the years, I have learned the range of shapes that is made by falling water – the various combinations of mounds and feathers. But in waves, the water is exploding. Good photographs taken in strong sunlight are a great help. It is quite hard to come by these, and I have had many adventures in my quest for the perfect wave in the perfect light.

In addition, tonal accuracy is even more important – if that is possible. You have to throw away preconceived notions about the water being lighter than the background, because very often it is not – you can get spray against a light sky that is grey against the light.

**BREAKING WAVE, KYNANCE COVE** 28 x 38cm (11 x 15in)
These small waves were breaking over sand on an incoming tide. Because they were very soft I used NOT (cold-pressed) paper instead of my usual Rough. All the whites were made by reserving the paper, and I used plently of water and wet paint for the softness of the waves.

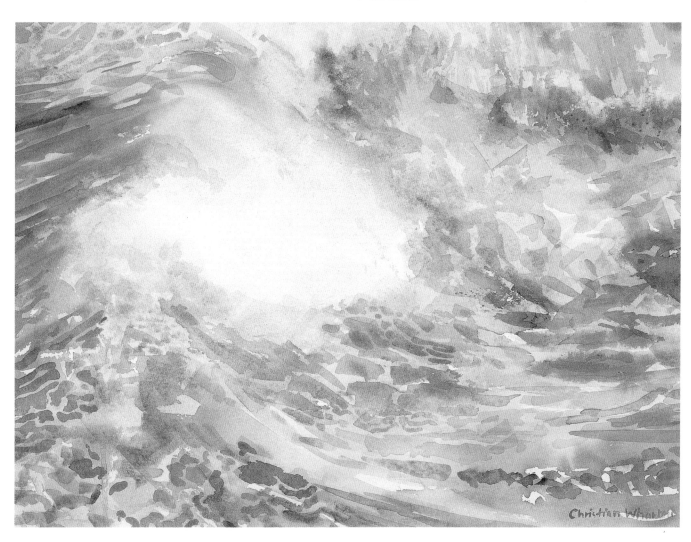

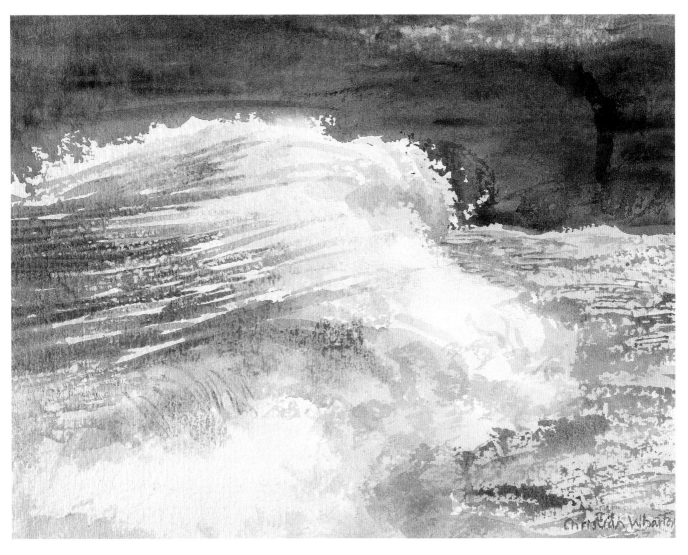

**ORKNEY WAVE** 28 x 38cm (11 x 15in)
I used the flat of the brush to paint the waves. The rocks at the back were done with wetter paint. As an afterthought, I added the sparkling sea behind the rocks to break out of the dark shapes by wetting it and scraping with a scalpel.

# Breaking wave, Mallorca

Catching a breaking wave, like this one in Mallorca, requires being in the right place at the right time – unlike a waterfall, which stays in the same place and is repetitive, each wave is unique and different. For this exercise I used masking fluid splattered onto the surface with an old toothbrush, and everything except the final details was painted with a large flat brush.

**THE SOURCE PICTURE** (courtesy of Elaine Townley)

1 Dip the toothbrush in the masking fluid and wipe off any excess, then hold it close to the paper surface and flick across the bristles. Allow the fluid to dry.

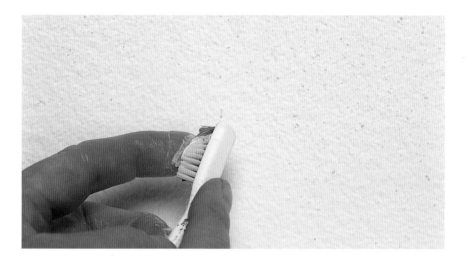

2 Start the sky area with diluted blue, and touch in the shadows on the white spray. Use a green-yellow mix for the water near the shoreline.

3 Darken and add texture to the foreground rocks with a combination of blue, green, yellow and magenta, using more magenta for the water in front of the wave on the right. Use the tip of the brush and deep blue for the sea at the horizon, working into the white lightly and softening any hard edges with water or by blotting with a tissue.

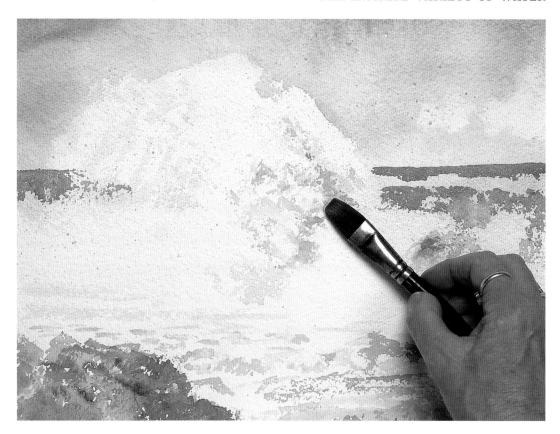

4 Continue to build up the foreground through layering colours rather than solidifying areas. Work gently into the white spray to show the different colours and shadows, and darken the rocks to show the shadows that suggest strong sunlight.

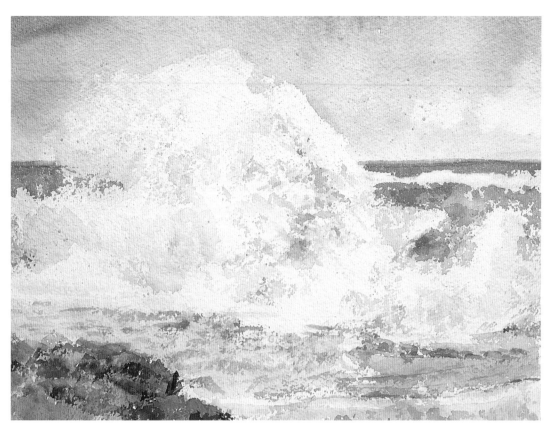

5 Reinforce the horizon, being careful to keep the edges soft, particularly the lower one. Working lightly, build up the shadows in the spray, and then add a very diluted wash for the sea behind and beside the rocks across the whole foreground area – but don't cover too much of the white at this stage.

6 To create a more amorphous area where the spray meets the sky, soften or reinforce edges as required. Darken the sky area to give greater tonal contrast with the wave, and apply and dab off very light washes of blue and magenta mix to add variety and movement to the sky.

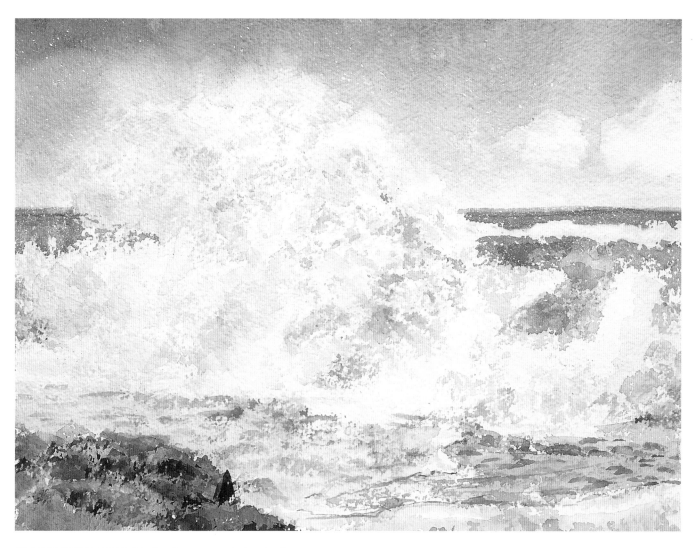

**THE FINISHED PICTURE** Continue to work the shadow washes over the white spray area, blotting off excess colour with a sponge or tissue and clean water. When the last washes are completely dry, scrape off the spattered blobs of masking fluid. Finish by adding the last foreground details with a small round brush, but don't overwork the picture.

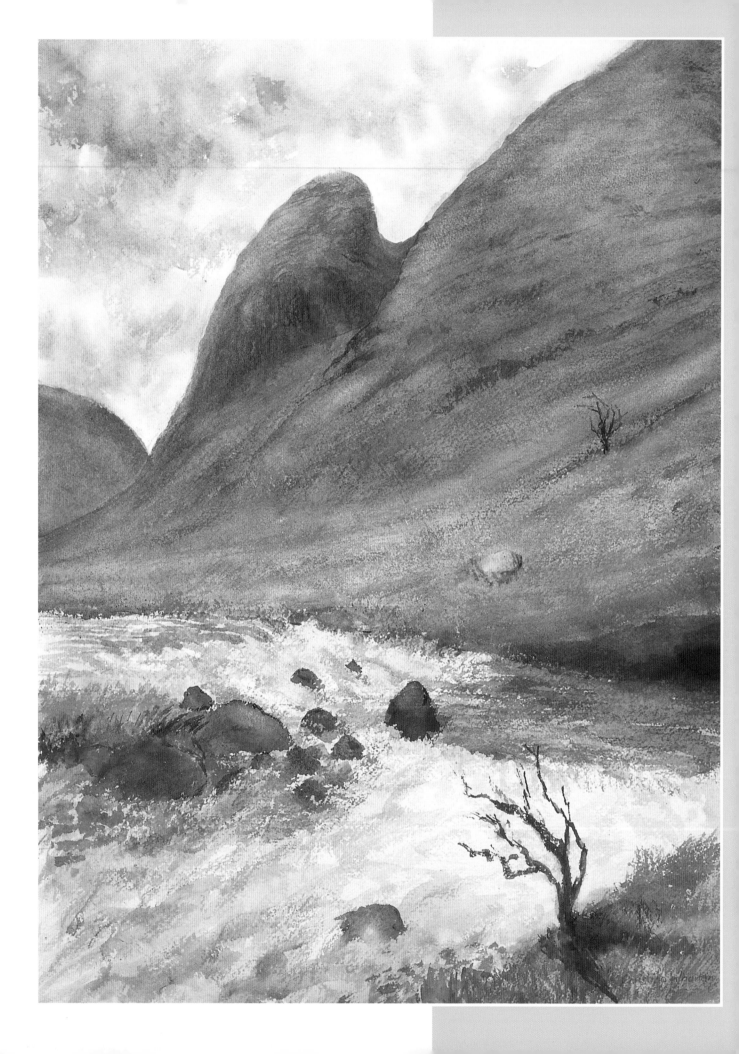

*'And gurly grew the sea.'*

*Ballad,* The Daemon Lover

# *chapter 7* Troubleshooting and finishing touches

Earlier chapters discussed the twin processes of organization and inspiration, and how eventually the ideal situation develops when the two go hand in hand and you just paint as you want to – without any apparent organization or effort. However, this doesn't happen all at once; careful thought and organization are very important. So how do you get to that carefree stage when there is so much analysis and decision involved? The answer is that you learn by getting it wrong. Mistakes are part of the process of education.

**DEIRDRE'S SEAT** 76 x 56cm (30 x 22in)
This is the finished picture from the exercise on pages 112–13. I rescued this painting by adding fictional details to the landscape to counterbalance the shape of the mountain. The trees in the foreground and middle distance are carefully positioned to lead the eye through the painting.

# Mistakes and overworking

I have done many 'effortless' paintings that made me either very absorbed or very happy when I was doing them, only to realize afterwards that they were not the product of inspiration and intellect working hand in hand – only delusion and stress release. There isn't anything inherently wrong in this – it happens quite innocently. (And after all, we all need therapy from time to time!) But the important thing is to recognize a failed painting for what it is, and put it in the reject bin. (By the way, I never tear up anything on the strength of an impulse that it is not worth keeping. It stays in the reject bin for some time before it is finally junked, and I suggest that you do the same with anything that you want to reject.)

There are some paintings that, although not the product of stress release, are never going to make it somehow. Sometimes this is due to a poor photographic reference, or sometimes the composition doesn't really work and can never be made to. This is because what I had observed worked in three dimensions helped by the air and the general ambience – things that cannot be replicated in two dimensions in the studio.

There are also paintings which I have done from memory and imagination, in the lack of anything better to record my subject – not having Turner's brilliance and capacity for visual recall, these have flopped.

Still other paintings just don't seem to quite come off. These are the ones that are right in parts, but not in others; or maybe I have become obsessed with one part and this is stopping me from noticing an area that does require attention. These I tend to keep because there might be something that can be done to rescue them after they have had a rest.

I have received two pieces of helpful advice about what to do when it all seems to go wrong. One was from a furniture restorer who said that the difference between an amateur and a professional was not that the professional didn't make mistakes, but that s/he knew what to do about them and was never fazed by them.

The other was from an artist in Boston, Ruth Cobb, to whom I showed my portfolio. 'I think this one is a little overworked,' I said of one of my paintings. 'Nonsense, it is not worked enough,' said Ruth and showed me one of her beautiful paintings in which she had had a struggle. Nothing of the struggle showed.

What she said started me thinking and I realized that when I thought something was overworked, what was really happening was that I felt I was overworking. It is a subtle difference, but an important one that brings me back to what I said at the beginning: painting is a journey of self-discovery. You find things out about yourself and learn how to adjust them in little but profound ways. If you ever feel bored or overworked in a painting, this is what your painting will reflect back to you. It should never be drudgery.

What both the furniture restorer and Ruth were saying is that it boils down to attitude – and this is the most important thing. There are two points here. One is persistence – never give up. And the other is detachment. Don't get too involved.

But it is all very well to say this – how do you achieve it when you are feeling miserable and even angry with what appears to be a failure?

The first thing to do is to give it a rest for the length of time that it needs, whether this is five minutes, a week or a year. This will help you to look at it again and see what's wrong. Then you can deal with yourself.

## Putting yourself right

The primary thing is to deal with what is going on in your mind. If it is full of disillusion and doubt, you will never be able to get the painting right. I have seen students, often young ones, get angry and tear up paintings that had very little wrong with them, just because the painting didn't come up to the self-inflicted standard of the version in the mind's eye.

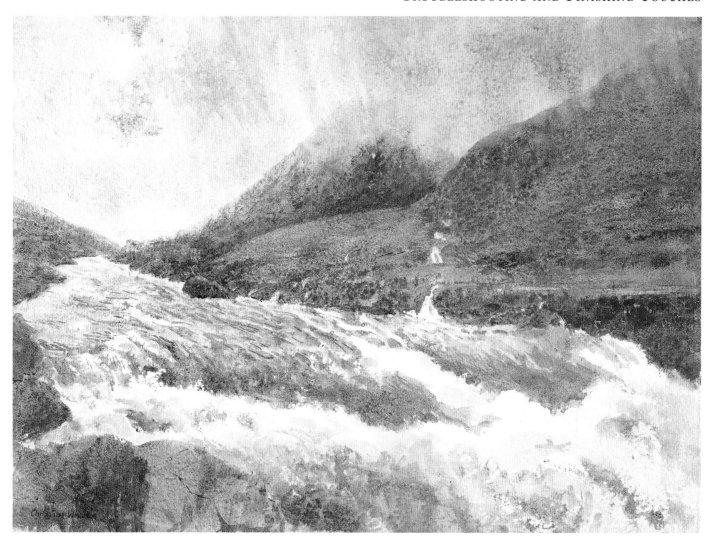

**RIVER ETIVE IN SPATE** 56 x 76cm (22 x 30in)
On a rainy, windy day with huge masses of water pounding down the glen, I wanted to get a misty effect as well as the chunky tussocks of grass. I used sponging out for the mists, and allowed raw sienna to soak into the hollows of the Rough paper to give the grass effect.

You have to remember that in the process of learning, mistakes have to be made. It is best to make lots of mistakes by painting in a confident sort of way – because mistakes can teach us so much about what art is about. My maths teacher had a way with us when we complained about being stuck: 'I'm glad you're stuck… it's really good for you to be stuck, because when you are stuck then you have a chance to work something out for yourself – in other words, to learn something!' He would never tell us the answer, though he might just, if he was in a good mood, let out a few hints.

## Differing factors

The next thing is to look at the painting from a different angle. Try turning it upside down or look at it in the mirror. I keep a mirror in my studio and don't know what I would do without it.

Often the problem is to do with becoming obsessed with detail. This prevents you from seeing the whole. It is possible that one detail is wrong and sometimes it can be very hard to get it right, but when something is a struggle, what happens is that you begin to hate your work and also yourself. The problem is elsewhere.

## Composition

Composition is often the reason a painting doesn't look right. I repainted a picture recently that I started many years ago. It was full of beautiful passages, but it had a huge compositional weakness that I only understood when I looked at it again.

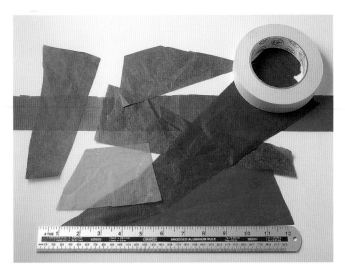

**RESCUE TOOLS**
Tissue paper, masking tape and ruler.

**EXPERIMENTING WITH TISSUE PAPER**
Placing white tissue paper over a seascape shows what it would look like if the tones were raised.

One of the best ways you can look at your painting to see if the composition can be improved, is to cut out shapes of coloured paper – I have a collection of coloured tissue papers, which is very useful – and place them on the painting to see if the general dynamics can be improved. This way you can't do anything to hurt the painting and you can begin to see it differently. Sometimes you can just help it by masking off a section with a strip of white paper – this may show you that all you need to do is to cut it down and make it into another shape.

## Tone

Another thing that can go wrong is, dare I say it, tone. Looking with half-closed eyes at the painting upside down or in the mirror is the greatest help here. I have learned a great deal about tone in the last 20 years. Looking at my earlier paintings, I can now see that in many of them the tones are wrong – the water is too white.

It is not too hard to adjust tone. You can put washes over a whole area to bring the tones together, or you can sponge out an area that is too dark. This is one of the joys of watercolour – it is so easy to lift off dark paint if you are using good-quality paper.

I have, on occasions, put paintings in the bath and given them a scrub under the cold tap. However, it is not possible to bring black completely up to white, without damaging the paper. This doesn't matter from a general viewpoint, but if you have to put fine detail or lines down with the point of a brush, you will find that it will no longer lie properly because the paint will sink into the minute cracks in the battered surface of the paper. It makes the image on the paper very blurred and impressionistic. If necessary, you could consider getting round this by using acrylic paint.

## Edges

Linked to the matter of over-obsession with details is the question of edges. These, whether of rocks or mountains or water, are very rarely hard. They can dry hard and need to be softened unless this is an effect

**SOFTENING EDGES**
The edges of the building in this painting were too sharp and hard, so I softened them with a wetted cotton bud.

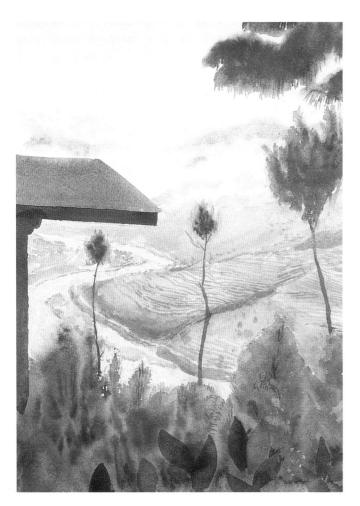

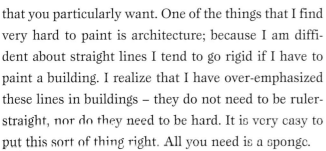

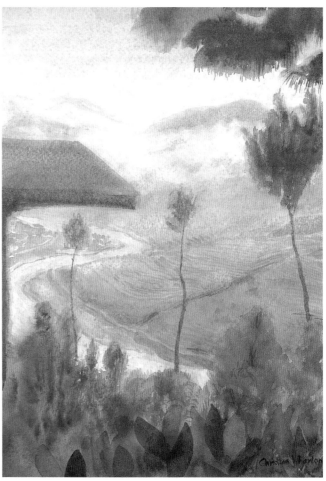

that you particularly want. One of the things that I find very hard to paint is architecture; because I am diffident about straight lines I tend to go rigid if I have to paint a building. I realize that I have over-emphasized these lines in buildings – they do not need to be ruler-straight, nor do they need to be hard. It is very easy to put this sort of thing right. All you need is a sponge.

## Drawing

The drawing can be wrong. You have to check your source material. Look again at your subject, your sketches and, if you are using them, photographs.

If you are not sure about the drawing, one of the things you can do is lay a piece of tracing paper over your painting and draw on it with a pencil, making several versions until you get the one which seems right. It is much better to do it this way than to try and correct the drawing straight onto the picture with a fine-pointed brush and rather dry paint, because you can't always be sure how it should go.

**CORRECTIVE WORK**

Starting with the painting above left, I softened the hard edges on the building and sponged out a lot of the middle ground to make it more misty. I also darkened some of the foliage in the foreground and extended the tree at the top in order to make a stronger frame for an effect of more recession (above right). By darkening the middle distance I made the river gleam.

Sometimes I just take a picture that has gone wrong and have some fun with it because it isn't always possible to analyze what it is that has gone wrong, and playing about and changing it sometimes produces a painting which is true to itself. You can learn a lot by playing with a painting in this way – just letting go and seeing what happens. Sometimes nothing – but just occasionally there is a surprise.

Finally, and this is the main reason for not rushing to destroy a picture, just sometimes your perception of it is wrong and it actually is a very fine painting. You might have found it hard to do or perhaps you worked too long and got tired and you don't want to look at it for a bit. So don't admit defeat. Ever.

# Correcting a problem painting

This view of Deirdre's Seat, in Glen Etive in the Scottish Highlands, doesn't work because it is lopsided – everything falls off the bottom left-hand side. Parts of it are good, such as the sky, but the main problem is that I painted what was there! A little judicious rethinking added much-needed dynamics to the bottom half and made for a better painting.

**THE ORIGINAL PAINTING**

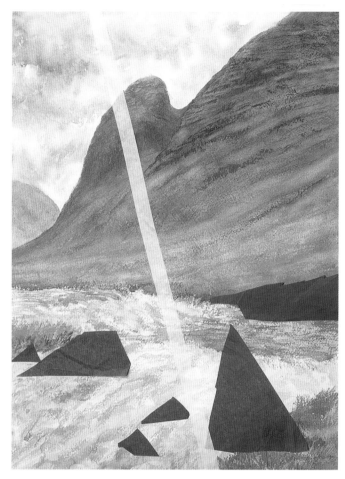

1 To move away from the inexorable leftward flow, I put a strip of masking tape down the picture in the opposite direction, then added some triangular shapes of brown tissue paper to see if breaking the composition with dark might work. (Using white tissue would have the opposite effect.)

2 To quietly direct the eye away from the main pull, I added a few directional marks along the left-hand side of the masking tape. I then softened the horizontals across the whole of the top right mountain by applying clean water over it and dabbing and wiping it off with kitchen roll.

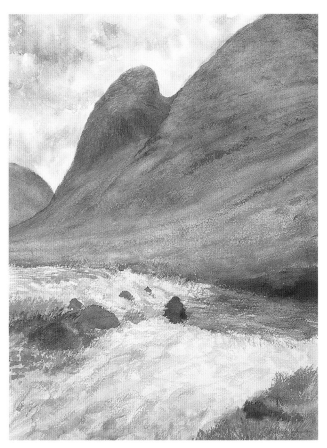

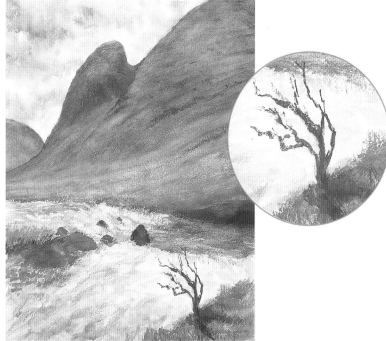

4 To match the tissue triangle at bottom right, I added a small tree, bent over by the wind in the direction indicated by the masking tape marks.
**Inset:** To soften the effect, I added the tree's shadow.

3 With a mid-strength blue, I darkened the left-hand hill, then added darker blue and magenta to the left-hand bank. I painted some stones and rocks across the river, following the shapes and positions of the tissue paper roughly.
**Below:** I darkened the new shapes with green-brown mixes.

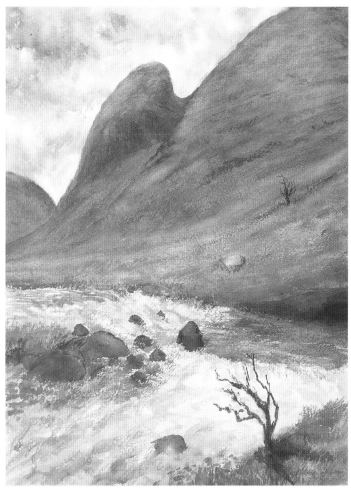

**THE FINISHED PICTURE** To bring the reworking to a conclusion, I softened the lines to the distant left-hand hill and along the hills to the sky. I added a little tree and a boulder to break up the strong sweep of the right-hand hill, and a few more stones and pebbles in the river.

# Finishing touches

People ask me how long I take to do a painting. I never really know, so I say 'about two days'. This is and isn't the truth. Setting aside the process of gestation, which can take many years, the time I take to make a painting can be quite short.

Unless the painting is mostly very white water and very white snow, there comes a point when the paper is too wet to take any more paint and has to be left to dry. So I usually have more than one painting on the go,

which means that I never do two days concentrated work on one painting. And if I do finish the major part of a painting within two days, there is a period of rest afterwards during which it goes up on the wall and is looked at in different times of the day and moods, as well as in the mirror.

## Housework

Things come up during this period. I call them 'housework'. They are usually a matter of tidying up, without becoming obsessive. I have to look carefully and see that the image is clear and simple, and to correct any mistakes in drawing and composition. It really is a modified form of troubleshooting, although if this is a

**BRIDGE, BHUTAN** 28 x 38cm (11 x 15in)
There is a strong horizontal movement with the line of the little foot-bridge, the path and the leaves of the banana palm. I counterbalanced this with strong vertical movement in the line of the waterfall and the lines of the palm leaves in the foreground.

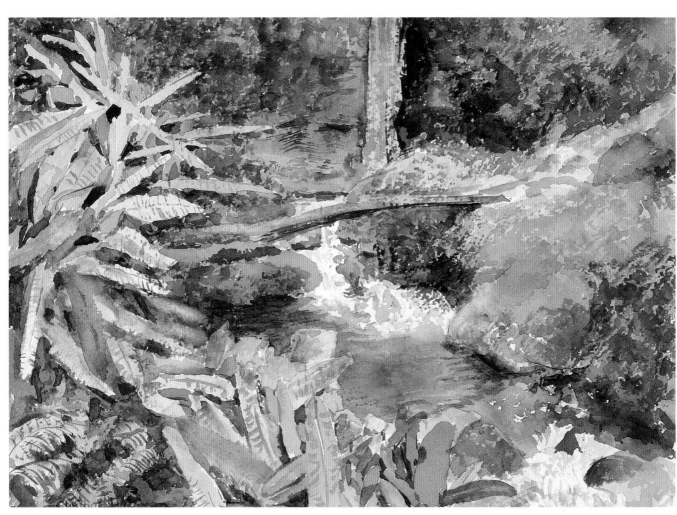

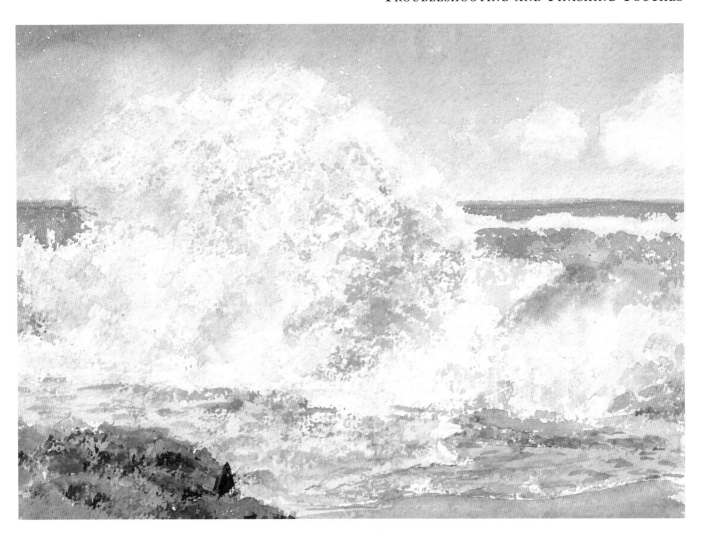

painting I am pleased with, I find that I am softening edges and making sure that if anything is behind anything else, it looks as if it is meant to be there.

Sometimes it is a matter of tying things up – making marks which help to connect the composition and lead the eye around the painting. It is wonderful how a few small marks can alter the balance of a composition.

The parts should be subordinate to the whole; this sometimes means washing over a detail that has become too dominant. It is time to look from a distance or even with unfocused eyes. The focused ones tend all the time to look for 'what is wrong with this little bit' or fussy little details. You have to round off the whole thing.

## When to stop

From what I have said about troubleshooting and reworking paintings that have been left fallow for long periods, it looks as though I can never really tell when a painting is finished. But this is not so. On the whole,

**SECOND THOUGHTS**

Since doing this demonstration painting, I noticed several things wrong with it. There was a lumpy piece of wave on the right-hand side (see page 105), so I took it out. I softened some detail in the middle of the remaining wave, and strengthened the foreground shoreline.

there comes a moment when everything is either satisfactorily in balance or else beyond all hope of redemption.

There comes a point when there is nothing more you can do with a painting – if it does not satisfy you, then you can always do another. This is why it is so important to get the motivation right at the start.

This might seem to go against the idea of reclaiming paintings that are not quite right. But the point is that you are working for yourself, as you are at any particular stage. You can come back now to a painting which you could not do anything with at the time, and find that it is possible to redeem it. That said, on the whole, I prefer to start again. There is something so enticing about fresh white paper.

# Framing

Having finished a painting to your satisfaction, you may want to hang it up on your wall. First, however, don't even think about making your own frames. It is extremely difficult to cut glass, and even if you buy it ready-cut, it's just as difficult to cut good mounts and make good mitred corners on the frame – that is, unless you have very expensive equipment. It is much better to use your local framer.

If you have used lots of water in your painting, you may find that the paper has buckled as it dried out. Your framer will want it to be completely flat, and it does look much better like this. All you need to do is to turn it over and lightly moisten the back with a squeezed-out moist sponge. Then put the painting between two sheets of blotting paper on a hard surface underneath a board with some weights on it – a load of books will do. Leave it for about 12 hours and it will come out flat.

Make sure that your framer uses conservation materials – acid-free board for the mounts and conservation standard tape for securing to the mount. Also, there should be a piece of acid-free board between the mounted painting and the hardboard backing. Full conservation framing is extremely expensive and not really necessary as long as these precautions are met.

It is expensive to have watercolours framed, but they do look good when it has been properly done. The traditional way is to use double mounts with about 6mm (¼in) between the outer and inner ones. Depending on the size of the painting – let us say 38 x 30.5cm (15 x 12in) – there should be at least 19mm (¾in) of mount at the top and sides and 8.8cm (3½in) at the bottom. (If the painting is larger, this should be more.) The whole thing is then glazed, which makes it heavy and hard to transport as well as hard to see in certain lights, but it does look good and helps to preserve it. Although the colours I have recommended are as permanent as possible, it is not a good idea to hang any watercolour painting in strong sunlight.

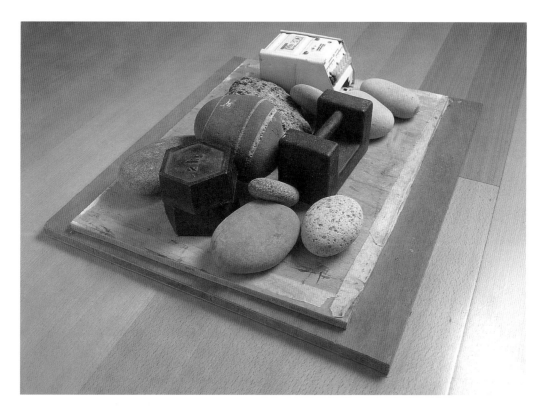

**FLATTENING A PAINTING**
After lightly dampening the back with a sponge, I place it between two sheets of blotting paper and then between two drawing boards, using stones and heavy objects to make a press.

## HINGES

The back of the painting is fixed to the mount with linen tape. Note the crosswise strip of tape for extra strength.

## BACKING

Once the painting has been hinged onto backing board, the whole thing should be fixed to the back of the mount with adhesive tape.

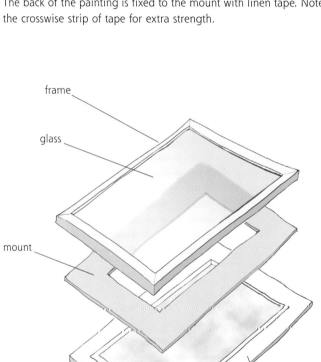

frame

glass

mount

painting hinged
to backing board

hardboard
backing

## INSIDE A FRAME

All mounts and boards should be acid-free, and all adhesive tape should be conservation quality, and there should be no masking tape anywhere near the picture.

## MOUNTS

A double mount on the left, and a single mount on the right.

back of frame

gummed paper

## FINISHING OFF

The frame should be finished off with a strip of gummed paper over the joins, where the frame meets the hardboard. This is to keep out insects.

# Postscript – final reflections on water

The German Pointer mentioned in the Introduction lived with a very simple philosophy. He believed that everyone in the world existed to throw sticks for him to retrieve.

He was immensely patient and resourceful in dealing with humans who had not yet discovered this simple truth about existence. Old or young, he would coach them patiently by dropping little sticks at their feet, until they made the rapturous discovery for themselves. I have seen him tackling toddlers barely able to walk and old men hardly able to bend down. (He taught me by retrieving rubbish I was throwing on my compost heap.) And when there were no suitable missiles handy, he was creative to the point of destruction, embarrassing me more than once by his ruthless ability to tear off branches of shrubs, such as a friend's cherished magnolia, purely to drop it at her feet, wagging his tail and making imploring noises.

I feel a bit like this about painting water – although I promise not to go to quite such great extremes! I believe that everyone should do it. It is enormously pleasurable in itself and it leads you back to the source of the inspiration, making it possible to see more and more of what you are looking at. If that means that you find you are spending an increasing amount of time with water, that is all to the good. And if this means that you will have more ponds in your garden, and fountains and waterfalls – that is, if anything, even better. We all have a very deep-seated need to be by water, the best antidote I can think of for the computer screen!

I have enjoyed writing this book because I have been writing about the great love of my life. I hope that some of this has washed off on you.

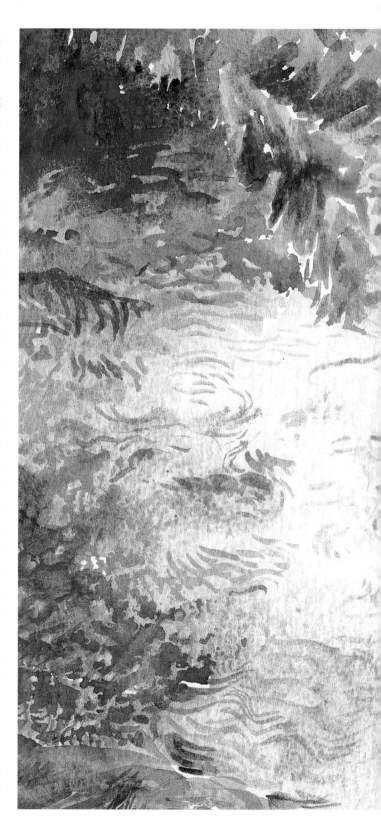

**RIVER BRUAR** 28 x 38cm (11 x 15in)
This is a very attractive small river in Perthshire, Scotland. The tones were very close and delicate. I wanted to suggest the connection between the rhythms in the water and the bankside foliage.

118

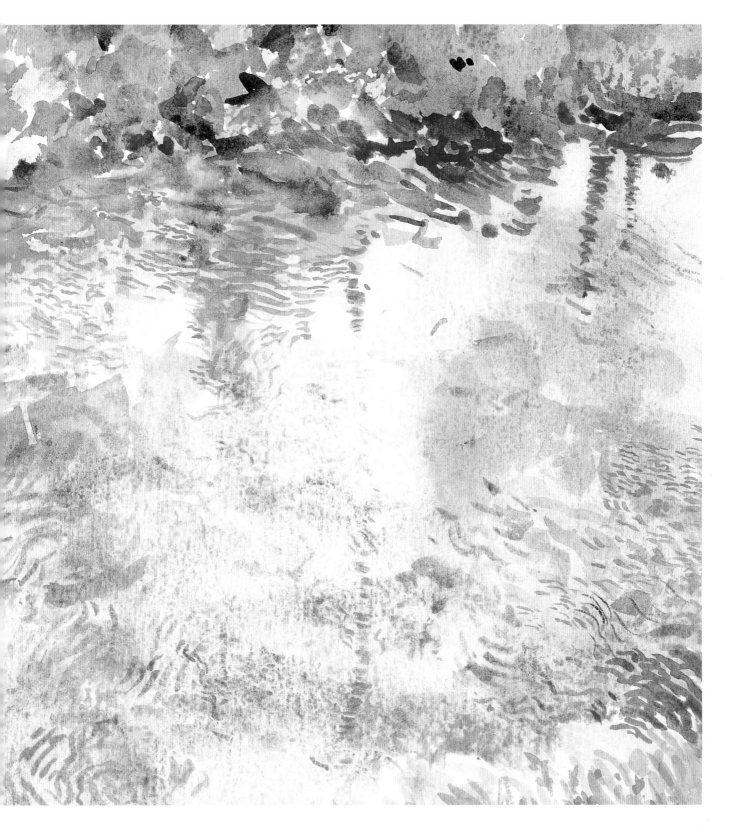

# Index

Illustrations *italic*

# Acknowledgements

My profound thanks are due to: Ian Kearey, Sue Cleave, and the rest of the team at David and Charles; to Duncan Wherrett for all his support; to Colin Baxter and Elaine Townley for permission to use their photographs; and finally to Amanda White, my agent and friend.

**WATERFALL, BHUTAN** 38 X 28cm (15 X 11in)
This was a side tributary, a non-glacial stream coming into the Mo Chu Gorge. There was a very strong contrast between the shaded left-hand side and the sunny right, due to the thin, clear air at high altitude. I used dry brushwork for most of the trees, washing over with a dark wash where necessary for the shadows.

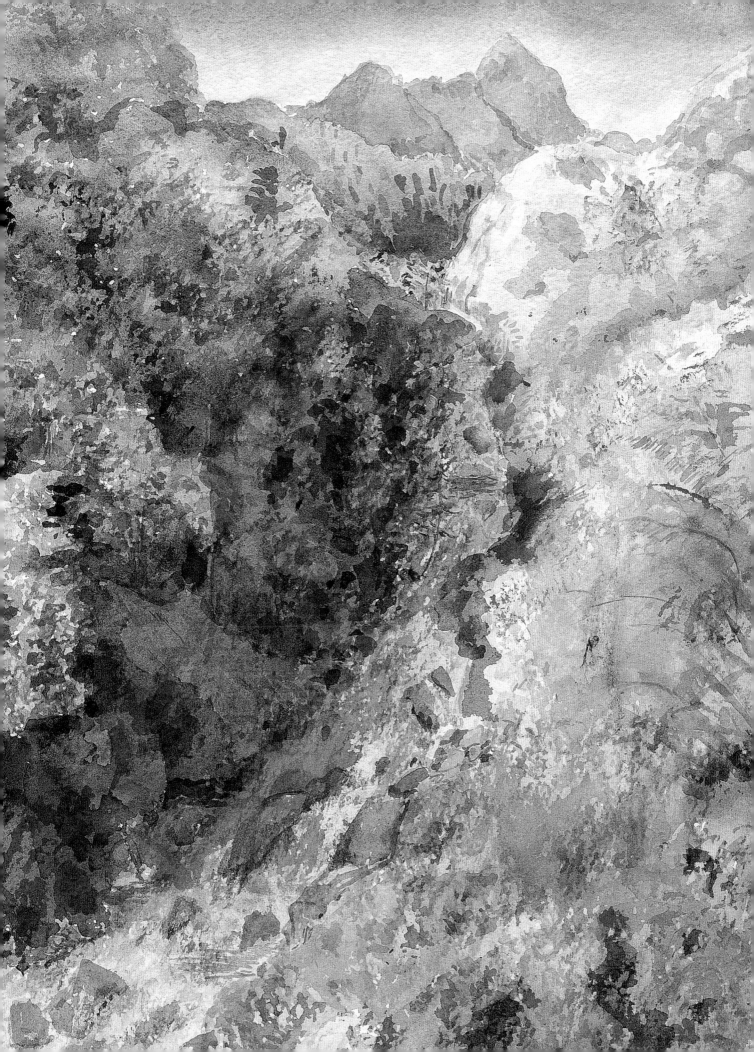